50 THINGS TO DRAW

METRO BOOKS
New York

An Imprint of Sterling Publishing Co., Inc.
1166 Avenue of the Americas
New York, NY 10036

ISBN 978-1-4351-4611-2

For information about custom editions, special sales, and premium and corporate purchases, please contact
Sterling Special Sales at 800-805-5489 or specialsales@sterlingpublishing.com.

Manufactured in China.

4 6 8 10 9 7 5

www.sterlingpublishing.com

Cover design by Amanda Tannen.

50 Creative Projects to
Unleash Your Drawing Skills

Ed Tadem

METRO BOOKS
New York

Table of Contents

Tools and Materials

Pencils

Drawing pencils are designated by hardness and softness. H pencils are hard and make a lighter mark, whereas B pencils are soft and make darker, black marks. I use a lead holder, which is similar to a mechanical pencil but holds only one lead at a time. I find this convenient because I can just switch out different leads and keep using the same pencil. Of course, you can also use good old-fashioned wooden pencils. I always use a rubber grip pad to minimize the strain on my hand and wrists.

Sharpeners

Mechanical leads can't be sharpened with regular sharpeners; you have to use a special sharpener, which you can find at art and craft stores (shown right). For regular pencils, you can use a hand-held sharpener or a sandpaper block.

Erasers

I use a kneaded eraser for most erasing—it can be shaped and molded to fit into small areas. And it doesn't leave those annoying eraser crumbs! Stick erasers are also great for getting into small areas. For heavier erasing, I use a regular white plastic eraser.

Artist's Tape

This tape is specially made to be sticky enough to hold your paper in place but not so sticky as to leave residue behind. It's also very easy to peel off without damaging the paper.

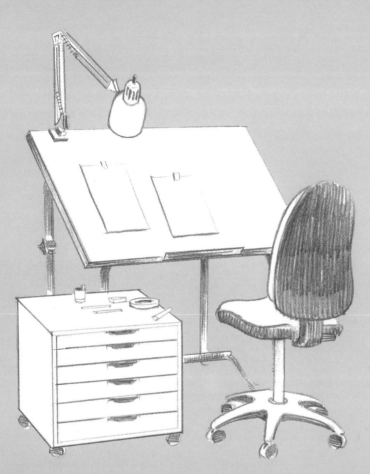

Workspace

I work on an angled drafting table, which keeps me from hunching over when I draw. I tape my drawing paper to the table with any references and preliminary sketches taped off to the side. I have an adjustable lamp on the left side because I'm right-handed; this ensures that the shadow cast by my hand will never obscure the area I'm drawing on. It's important to have a comfortable chair with plenty of back support. I also have a rolling cabinet where I keep paper and other supplies. I spread out my tools on top of the cabinet, too.

Paper

There are as many kinds of paper out there as there are leaves on trees, and each kind of paper provides different results. Bristol paper, which comes in pads or sheets, is a great choice for finished drawings. It's available in smooth (sometimes called "plate") or vellum (slightly textured) finishes. Whichever paper you choose, make sure it's acid-free to avoid yellowing!

Warming Up

Just as you warm up before working out at the gym, you should relax your hand and get comfortable holding the pencil before exercising your creativity. I usually warm up by drawing random squiggles and lines. Familiarize yourself with the different types of lines your pencils can create, and experiment with every kind of stroke you can think of, using both a sharp point and a blunt point. Practice the strokes below and on the next page to help you loosen up.

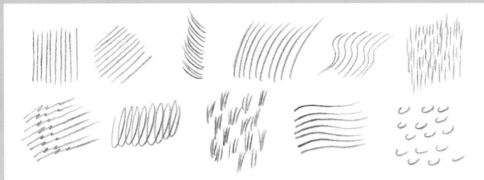

Drawing with a Sharp Point
First draw a series of parallel lines. Try them vertically; then angle them. Make some of them curved, trying both short and long strokes. Then try some wavy lines at an angle and some with short, vertical strokes. Try making a spiral and then grouping short, curved lines together. Then practice varying the weight of the line as you draw.

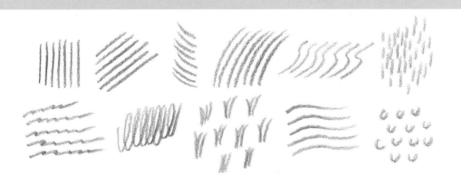

Drawing with a Blunt Point
Now try the same lines with a blunt point. Even if you use the same hand positions and strokes, the results will be different when you switch pencils. In the example above, you can see that the blunt pencil produced different images. You can create a blunt point by rubbing the tip of the pencil on a sandpaper block or on a rough piece of paper.

Starting Simply
First experiment with vertical, horizontal, and curved strokes. Keep the strokes close together and begin with heavy pressure. Then lighten the pressure with each stroke.

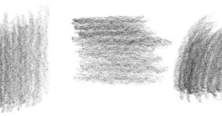

Varying the Pressure
Randomly cover the area with tone, varying the pressure at different points. Continue to keep your strokes loose.

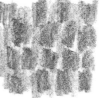

Using Smaller Strokes
Make small circles for the first example. This looks like leathery animal skin. For the second example (at far right), use short, alternating strokes of heavy and light pressure to create a pattern that is similar to stone or brick.

Loosening Up
Use long vertical strokes, varying the pressure for each stroke until you start to see long grass (at near right). Then use somewhat looser movements that could be used for water (at far right). First create short spiral movements with your arm (above). Then use a wavy movement, varying the pressure (below).

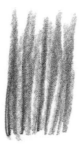
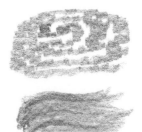

Finding Your Style

After a while, you'll notice that your drawings will all take on a consistent look and feel. Don't worry — it's just your own unique style coming through. To jumpstart this process, try experimenting with the different types of linework shown below.

Using Criss-Crossed Strokes

If you like a good deal of fine detail in your work, you'll find that crosshatching allows you a lot of control (see page 13). You can adjust the depth of your shading by changing the distance between your strokes.

Sketching Circular Scribbles

If you work with round, loose strokes like these, you are probably very experimental with your art. These looping lines suggest a free-form style that is more concerned with evoking a mood than with capturing precise details.

Drawing Small Dots

This technique is called "stippling" — many small dots are used to create a larger picture. Make the points different sizes to create various depths and shading effects. Stippling takes a great deal of precision and practice.

Simulating Brushstrokes

You can create the illusion of brushstrokes by using short, sweeping lines. This captures the feeling of painting but allows you the same control you would get from crosshatching. These strokes are ideal for a more stylistic approach.

Creating Form

Anyone can learn to draw by simply revisiting a lesson from grade school: Any subject can be broken down into variations of the three basic shapes—the circle, the square, and the triangle. Once you give form (or dimension) to the shapes, you'll have three-dimensional objects that seem to pop off the page. Try to think of the shapes on the left in the illustration below as real objects with solidity, depth, and weight. Then add a few lines to each to make them appear to have depth (see the center column). This is a basic example of using perspective, or the representation of objects in three-dimensional space (see page 14 for more information). Shading your objects with varying values—from black through grays to white—will give the shape form, as shown in the column at right.

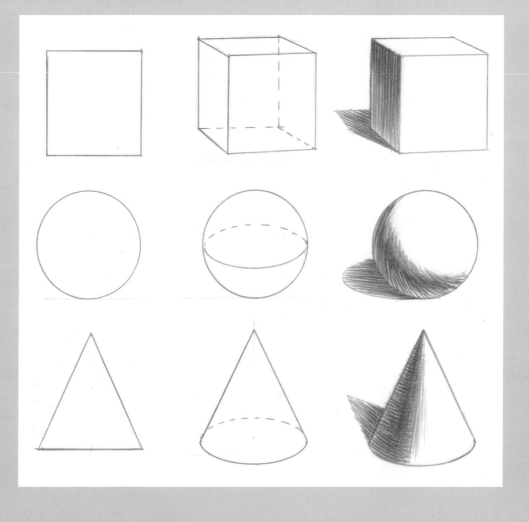

Light and Shadow

Shading gives depth and form to your drawings because it creates contrasts in *value* (the relative lightness or darkness of black or a color). In pencil drawing, values range from white (the lightest value) through different shades of gray to black (the darkest value; see the value scale below). To make a two-dimensional object appear three-dimensional, pay attention to the values of the highlights and shadows. Imagine the egg below with no shading, only an outline. The egg would just be an oval. But by adding variations of value with light and shadow, the egg appears to have form. When shading a subject, you must always consider the light source, as this is what determines where your highlights and shadows will be. Keep in mind that shadows get darker as they get farther from the light source.

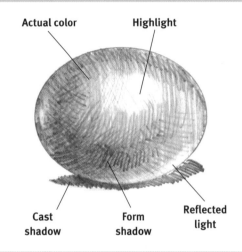

Actual color **Highlight**

Cast shadow **Form shadow** **Reflected light**

Identifying Values

The *highlight* is the lightest value and is where the light source directly strikes the object. The gray area between the highlight and the shadow is the actual color of the egg, without any highlights or shadows. The *cast shadow* is the shadow that the egg casts onto the ground. The *form shadow* is the shadow that is on the object itself. *Reflected light* bounces up onto the object from the ground surface. (Most people don't notice that one!)

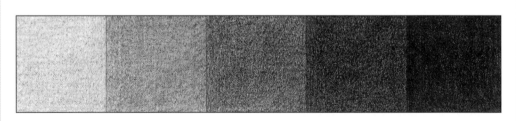

Value Scale

Making your own value scale will help familiarize you with the variations in value you can produce with a pencil. The scale also serves as a guide for transitioning from lighter to darker shades. Work from light to dark, adding more and more tone for successively darker values.

Basic Techniques

Below are examples of some of the most basic pencil techniques that you can use to replicate everything from smooth hair to rough wood. As you get your drawing skills into shape, you can experiment and try new techniques. Whatever techniques you use, though, remember to shade evenly. Shading in a mechanical, side-to-side direction, with each stroke ending below the last, can create unwanted bands of tone throughout the shaded area. Instead, try shading evenly, in a back-and-forth motion over the same area, varying the spot where the pencil point changes direction.

Hatching
For this basic shading method, fill an area with a series of parallel strokes. The closer the strokes, the darker the tone will be.

Crosshatching
For darker shading, place layers of parallel strokes on top of one another at varying angles.

Shading Darkly
Apply heavy pressure to the pencil to create dark, linear areas of shading.

Gradating
Apply heavy pressure with the side of your pencil, gradually lightening as you go.

Perspective Basics

To make a two-dimensional object look realistic, follow the basic rules of perspective to make it look three-dimensional. With linear perspective, objects appear smaller as they recede (imagine a road seeming to disappear in the distance). The two most important types of linear perspective are one-point perspective (where a subject is viewed from the front) and two-point perspective (where an object is viewed from an angle). Linear perspective is important when drawing cars and buildings.

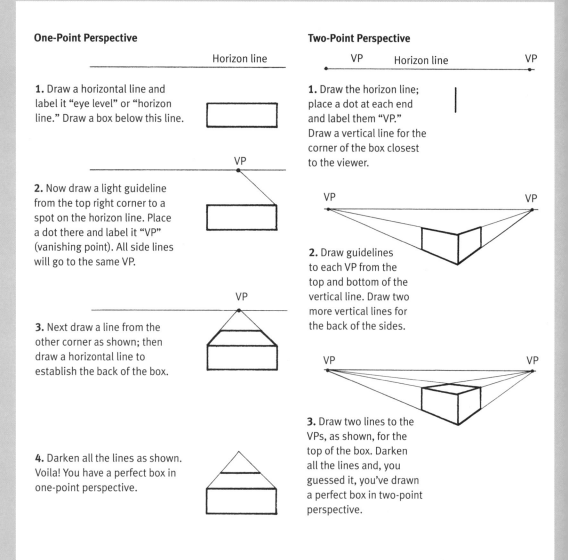

One-Point Perspective

Horizon line

1. Draw a horizontal line and label it "eye level" or "horizon line." Draw a box below this line.

2. Now draw a light guideline from the top right corner to a spot on the horizon line. Place a dot there and label it "VP" (vanishing point). All side lines will go to the same VP.

3. Next draw a line from the other corner as shown; then draw a horizontal line to establish the back of the box.

4. Darken all the lines as shown. Voila! You have a perfect box in one-point perspective.

Two-Point Perspective

VP Horizon line VP

1. Draw the horizon line; place a dot at each end and label them "VP." Draw a vertical line for the corner of the box closest to the viewer.

2. Draw guidelines to each VP from the top and bottom of the vertical line. Draw two more vertical lines for the back of the sides.

3. Draw two lines to the VPs, as shown, for the top of the box. Darken all the lines and, you guessed it, you've drawn a perfect box in two-point perspective.

Foreshortening

As you learned with linear perspective, things appear smaller the farther away they become. The same is true with parts of objects. *Foreshortening* is an important method of creating the illusion of depth in a drawing, and it works hand in hand with perspective in that the part of a subject that is closest to the viewer appears larger than the parts that are farther away. To create this illusion, just shorten the lines on the sides of the object that are closest to the viewer. (In other words, make that part of the object look bigger.) Don't worry if this sounds confusing — you'll get the hang of it.

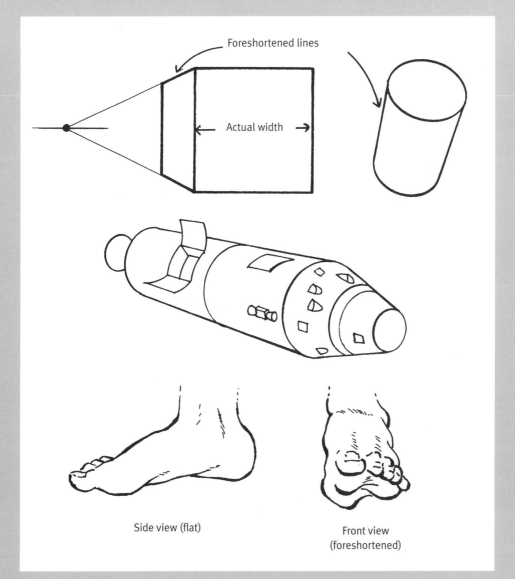

Foreshortened lines

Actual width

Side view (flat)

Front view
(foreshortened)

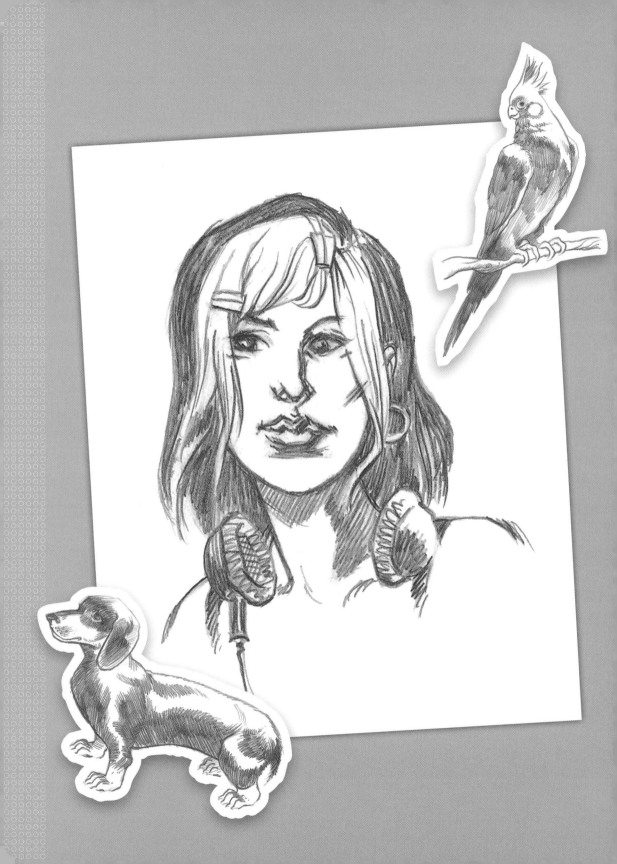

Animals and People

**Penguins tuxedo-like appearance is called "countershading" —
a form of camouflage, not drawing!**

step one	I start this little guy using an H pencil and basic shapes.

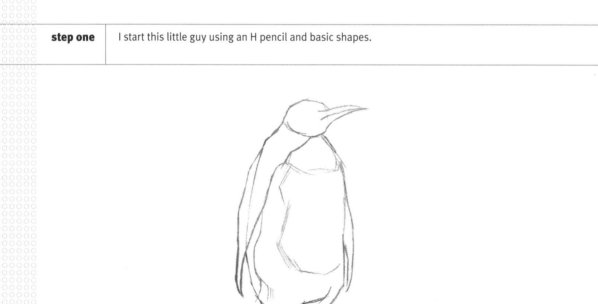

step two	I add the wings and beak, and I start fleshing out the feet and chest. I also draw the ground.

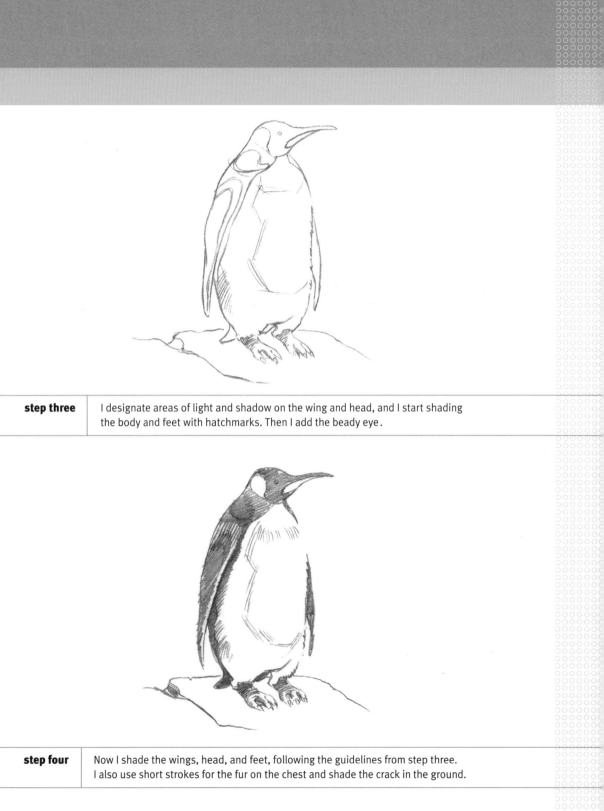

step three	I designate areas of light and shadow on the wing and head, and I start shading the body and feet with hatchmarks. Then I add the beady eye.

step four	Now I shade the wings, head, and feet, following the guidelines from step three. I also use short strokes for the fur on the chest and shade the crack in the ground.

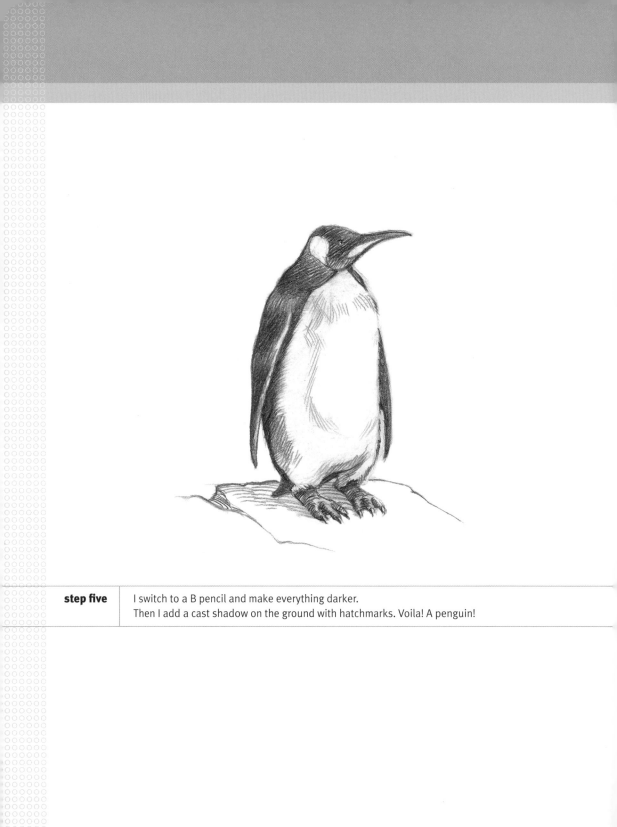

step five | I switch to a B pencil and make everything darker.
Then I add a cast shadow on the ground with hatchmarks. Voila! A penguin!

TIP

Don't be afraid to experiment and fail – remember, there's no substitute for practice.

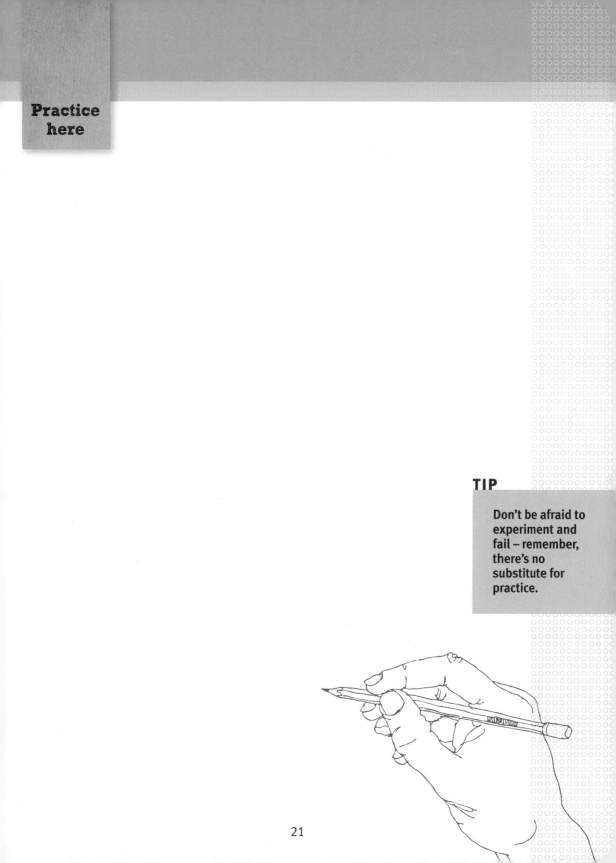

2 Snail

No need to rush when drawing this slowpoke; remember, slow but steady wins the race!

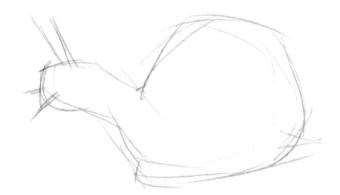

step one	I use an H pencil to draw a misshapen circle for the shell; then I add the neck, head, and tentacles.

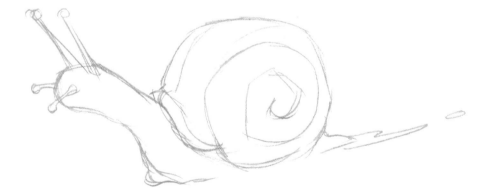

step two	I refine the basic shapes, defining the tentacles and adding the spiral pattern to the shell. I also indicate a "slime" trail.

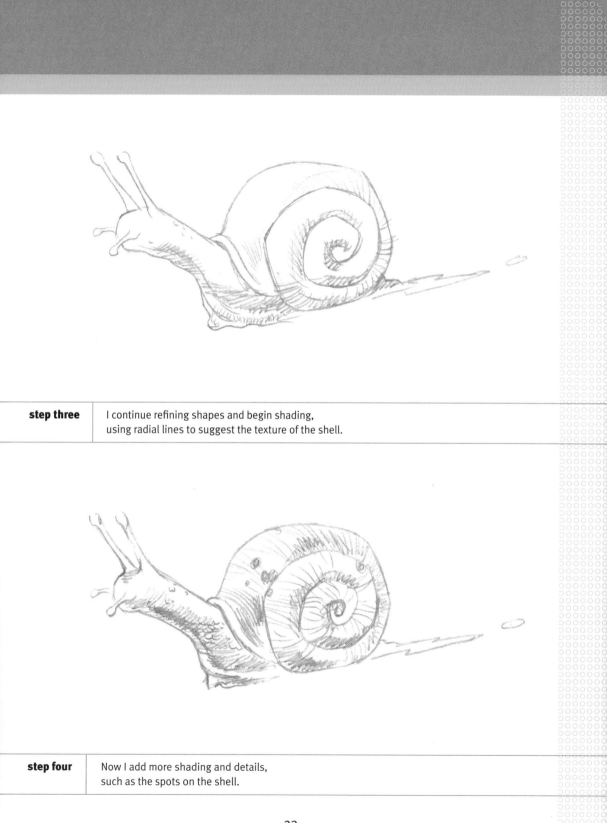

| **step three** | I continue refining shapes and begin shading, using radial lines to suggest the texture of the shell. |

| **step four** | Now I add more shading and details, such as the spots on the shell. |

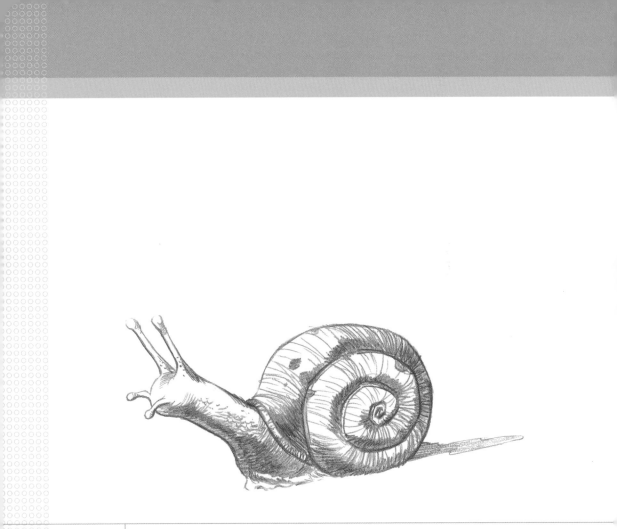

step five | With a B pencil, I go over all my lines, deepening the shading and creating the ridged texture of the shell. And he's off! (Sort of.)

TIP

Shading
creates three-
dimensionality.

Although the panda is a carnivore, its diet consists mostly of bamboo.
So, we'll add some to the drawing!

step one	With an H pencil, I start by drawing the rough shapes of the panda. In this sketch, I emphasize the belly of our round, fuzzy friend.

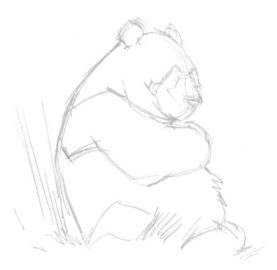

step two	I construct the features, adding the ears, nose, muzzle, and leg. I also decide that the panda should be sitting in grass...

| **step three** | ...and munching on bamboo (the two things they do best!). I continue refining the features, adding the eyes, mouth, and paw. Then I create more fur and grass. |

| **step four** | Now I tighten up my lines, erasing those I no longer need. I also add leaves to the bamboo and a few more details to the panda's face. |

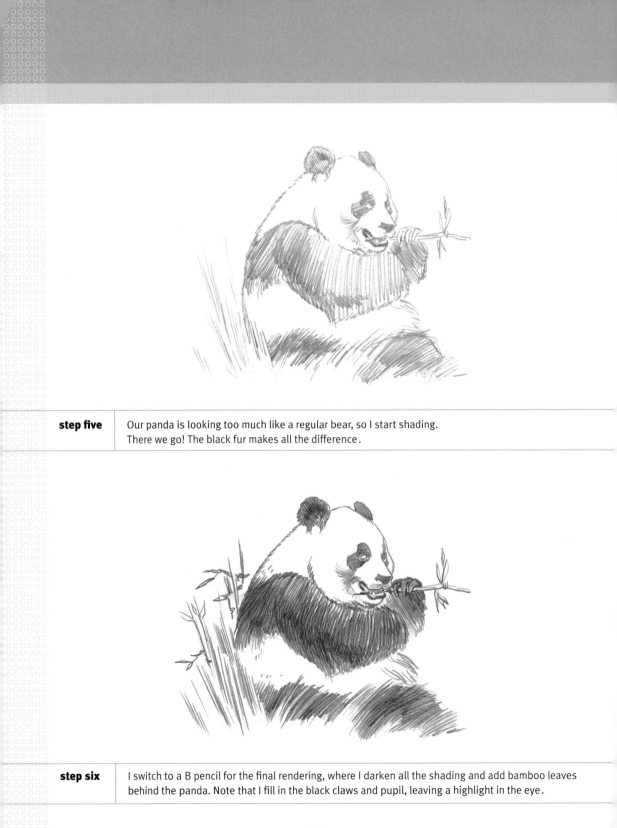

step five | Our panda is looking too much like a regular bear, so I start shading. There we go! The black fur makes all the difference.

step six | I switch to a B pencil for the final rendering, where I darken all the shading and add bamboo leaves behind the panda. Note that I fill in the black claws and pupil, leaving a highlight in the eye.

TIP

To minimize
the chance of
smearing your
drawing: If you're
right-handed,
work left to right;
if you're left-
handed, work
right to left.

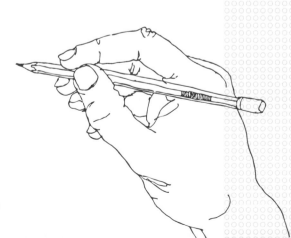

Everyone should have a horse in their stable of animals they can draw!

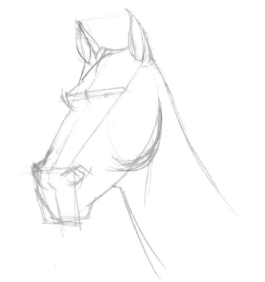

step one	Using an H pencil, I block in a tapered rectangle for the horse's head and a cylinder for the neck.	**step two**	Using the basic shapes as a guide, I create more defined shapes, such as the muzzle, ears, cheek, and browridge.

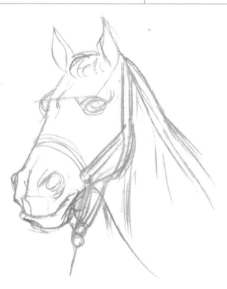

step three	Now I add details, such as the eyes, mouth, forelock, mane, and bridle.

| **step four** | After erasing any lines I no longer need, I refine the shapes and add more details to the face and mane. |

| **step five** | I clean up my lines even further, strengthening those I want to keep. |

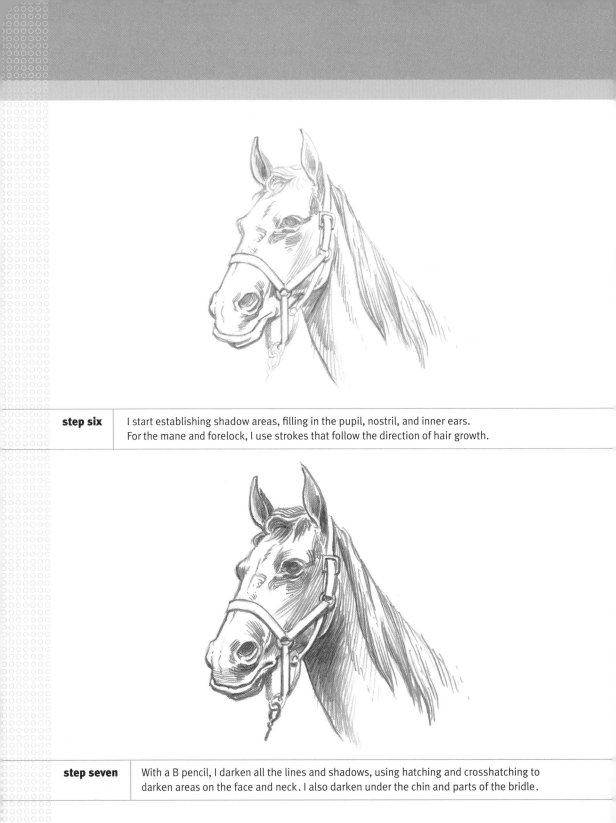

| **step six** | I start establishing shadow areas, filling in the pupil, nostril, and inner ears. For the mane and forelock, I use strokes that follow the direction of hair growth. |

| **step seven** | With a B pencil, I darken all the lines and shadows, using hatching and crosshatching to darken areas on the face and neck. I also darken under the chin and parts of the bridle. |

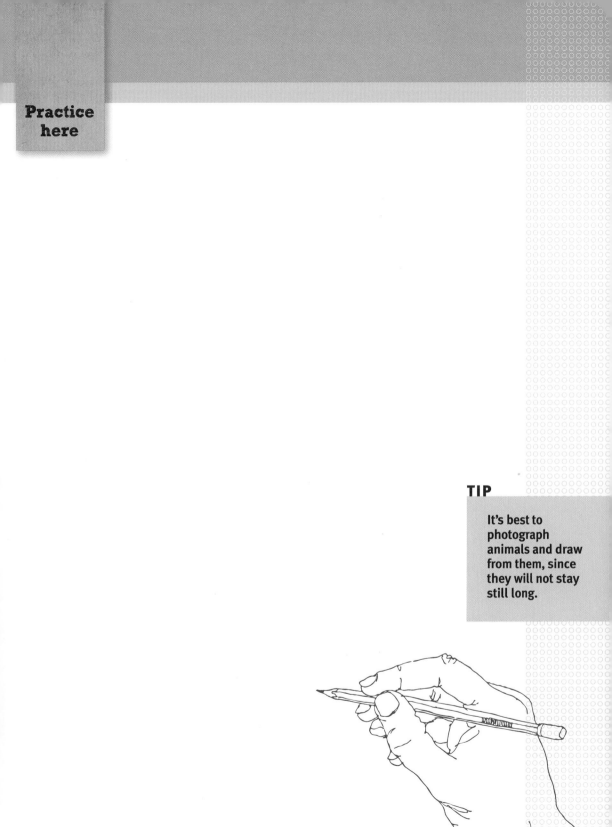

TIP

It's best to
photograph
animals and draw
from them, since
they will not stay
still long.

Your cat might ignore you, but your meow-velous drawings will surely gain attention!

step one	I want this cat to look like he's ready to pounce, so I make the back arched. Then I block in the head, facial guidelines, ears, paws, and tail.

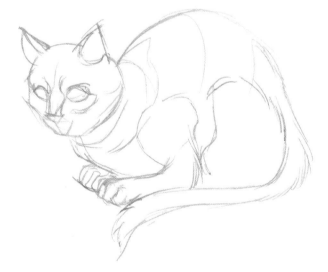

step two	I round out the shapes and define the toes. Then I start using short hatchmarks to indicate fur, and I block in the eyes.

34

| **step three** | I continue developing the face, shading the irises and pupils and drawing the muzzle. Then I indicate the stripes on the fur. |

| **step four** | I decide to start over with the eyes because they were looking too human, so I erase the shading. Then I continue to refine the lines and add more fur marks. |

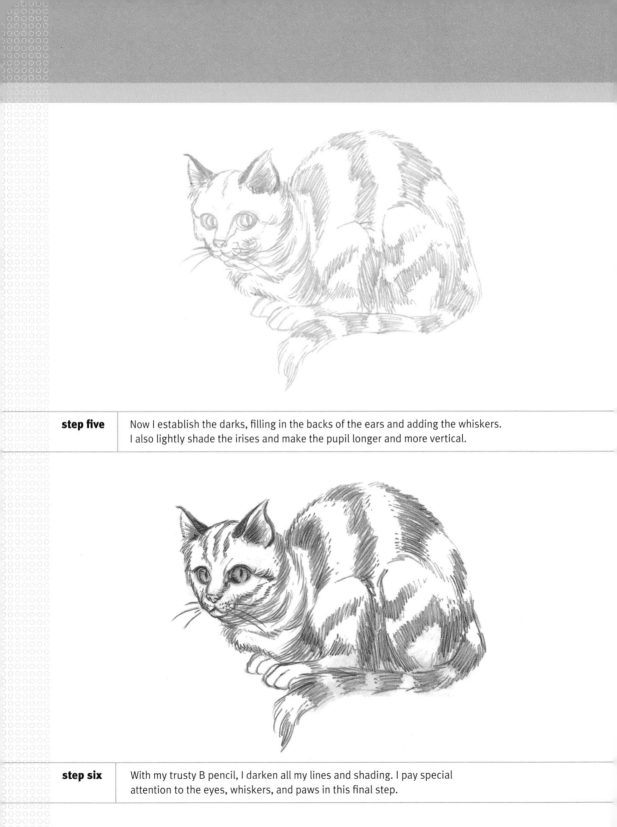

step five | Now I establish the darks, filling in the backs of the ears and adding the whiskers. I also lightly shade the irises and make the pupil longer and more vertical.

step six | With my trusty B pencil, I darken all my lines and shading. I pay special attention to the eyes, whiskers, and paws in this final step.

TIP

Real life
observation,
in addition to
referencing a
photo of the
animal, helps to
more accurately
capture details.

To begin drawing a seahorse's body, start with an "S"...

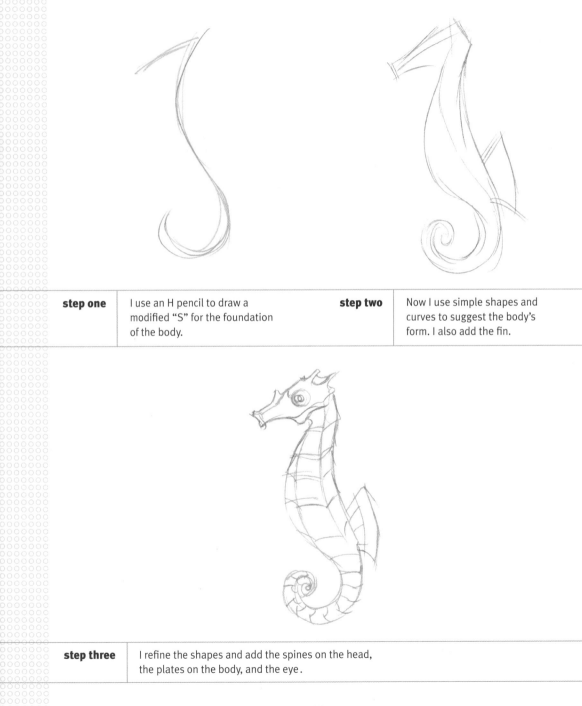

step one	I use an H pencil to draw a modified "S" for the foundation of the body.	**step two**	Now I use simple shapes and curves to suggest the body's form. I also add the fin.

step three	I refine the shapes and add the spines on the head, the plates on the body, and the eye.

step four	I add more details to the face and further define the body plates.

step five	I begin to lay down shading with hatchmarks, placing strokes closer together for darker areas. I also detail the eye and snout. I leave the ridges of the plates white to show the separation.

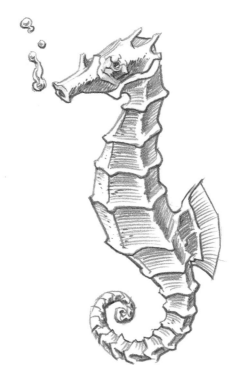

| **step six** | With a B pencil, I darken the lines and shading. I pull out highlights with a kneaded eraser where necessary and add a few bubbles escaping from the mouth for good measure. |

TIP

Seeing the
underlying shape
of what you are
drawing is vital.

Don't you think the head feathers on this bird look like a mohawk?

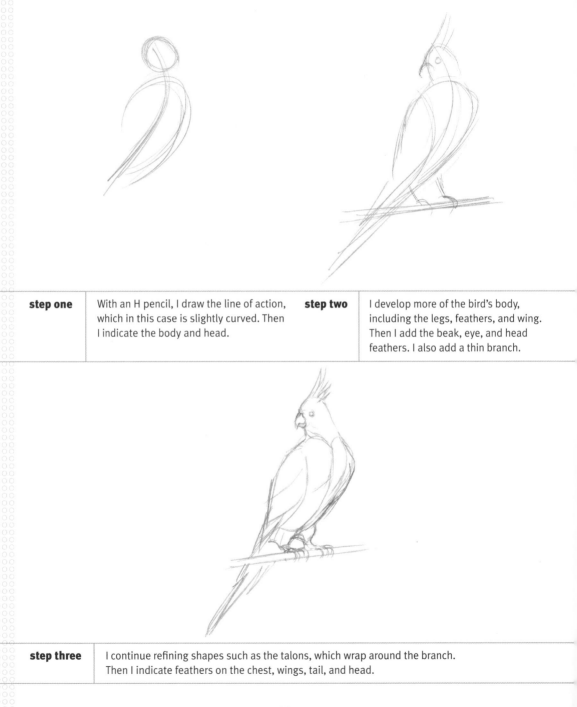

step one With an H pencil, I draw the line of action, which in this case is slightly curved. Then I indicate the body and head.

step two I develop more of the bird's body, including the legs, feathers, and wing. Then I add the beak, eye, and head feathers. I also add a thin branch.

step three I continue refining shapes such as the talons, which wrap around the branch. Then I indicate feathers on the chest, wings, tail, and head.

step four	Now I detail the feathers on the neck, chest, wing, and tail. I further develop the talons and face, and I make the branch thicker and curved so it looks more natural.

step five	I clean up my lines and start shading the underside of the tail. I also draw swirls and knots on the branch to make it look wooden.

| **step six** | I continue to lightly shade the figure so I know where the lights and darks will be. I also fill in the pupil. |

| **step seven** | Now I turn to the B pencil to create the darkest areas. I strengthen all the lines, especially the outlines of the talons, branch, and cheek. I also shade between the head feathers, giving them more dimension. |

TIP

By putting firm
pressure on
the pencil tip,
shading takes
on the direction
of your pencil's
movement.

Wiener dogs? I prefer to call them *haute* dogs.

step one	I start with a hot dog shape for the body (how fitting!), a small circle for the head, and a box for the snout. Then I draw the short legs.

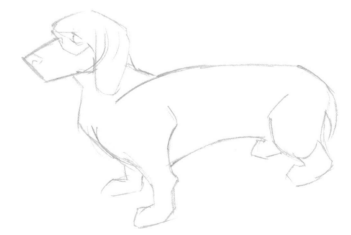

step two	I develop the stubby legs, draw the floppy ear and short tail, and block in the eye and nose.

| **step three** | I refine the forms and add the mouth and toes. Then I detail the eye and indicate areas of light and dark on the body. |

| **step four** | After cleaning up my lines, I begin drawing fur with zigzag lines. I also detail the claws. |

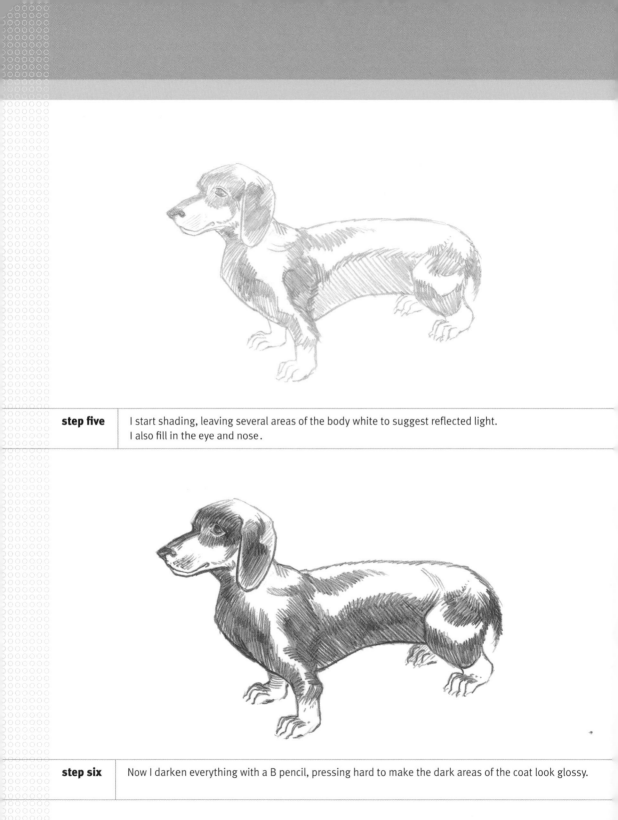

step five | I start shading, leaving several areas of the body white to suggest reflected light. I also fill in the eye and nose.

step six | Now I darken everything with a B pencil, pressing hard to make the dark areas of the coat look glossy.

TIP

A dog's nose is wet and leathery—an interesting combination of rough and shiny textures.

9 Turtle

Turtles have it easy—when they don't want to be bothered, they just pull their heads inside their shell.

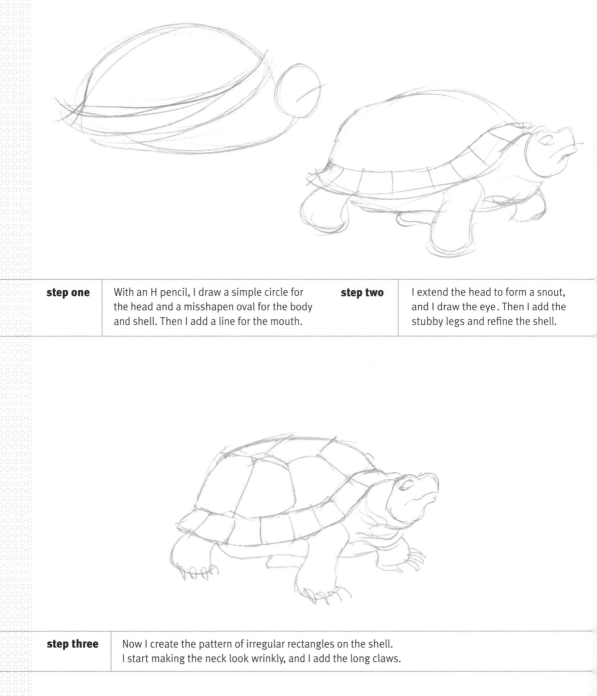

step one	With an H pencil, I draw a simple circle for the head and a misshapen oval for the body and shell. Then I add a line for the mouth.
step two	I extend the head to form a snout, and I draw the eye. Then I add the stubby legs and refine the shell.

step three	Now I create the pattern of irregular rectangles on the shell. I start making the neck look wrinkly, and I add the long claws.

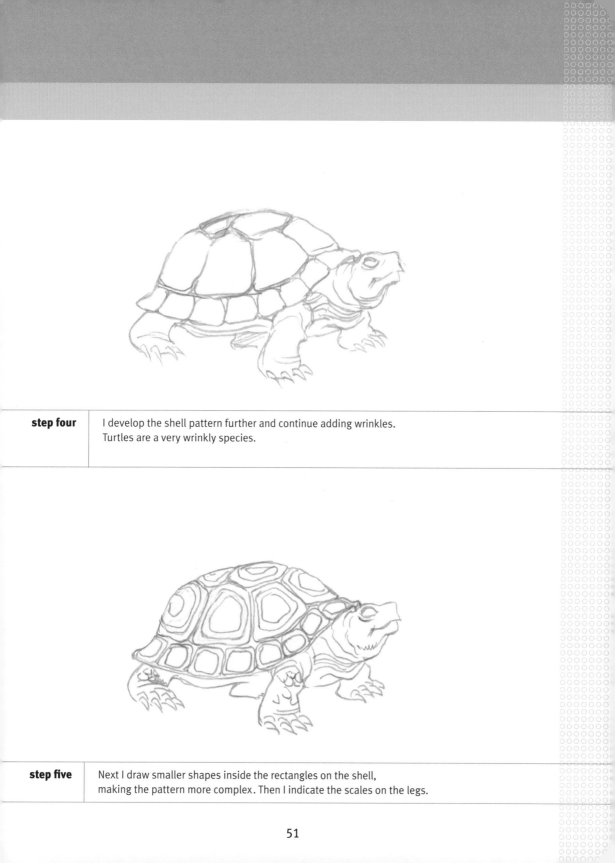

| **step four** | I develop the shell pattern further and continue adding wrinkles. Turtles are a very wrinkly species. |

| **step five** | Next I draw smaller shapes inside the rectangles on the shell, making the pattern more complex. Then I indicate the scales on the legs. |

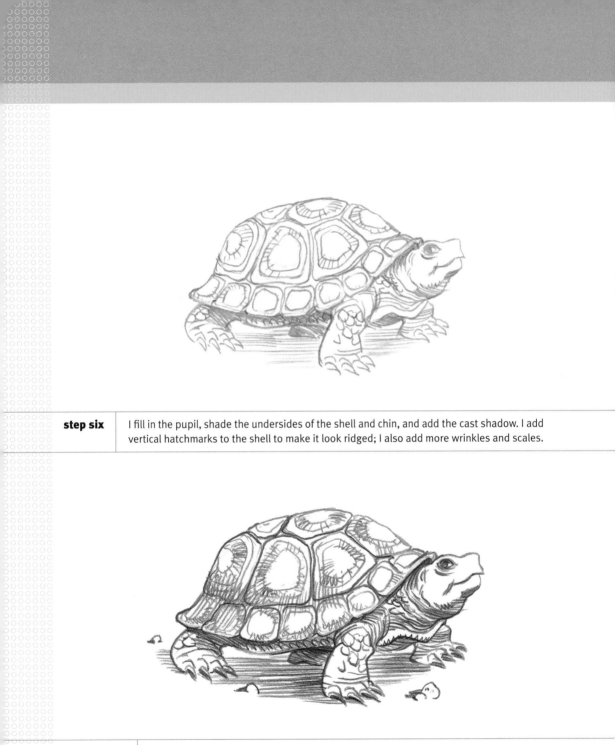

step six I fill in the pupil, shade the undersides of the shell and chin, and add the cast shadow. I add vertical hatchmarks to the shell to make it look ridged; I also add more wrinkles and scales.

step seven With a B pencil, I darken most of my lines and shading. I add hatchmarks to the shell and skin, making it look as textured as possible. Finally, I fill in the claws and draw pebbles that hint at the dry, dusty locale.

TIP

Use sections of
different photos
to create the right
combination for
your drawing.

When drawing animals with long fur, use long strokes. Easy, right?

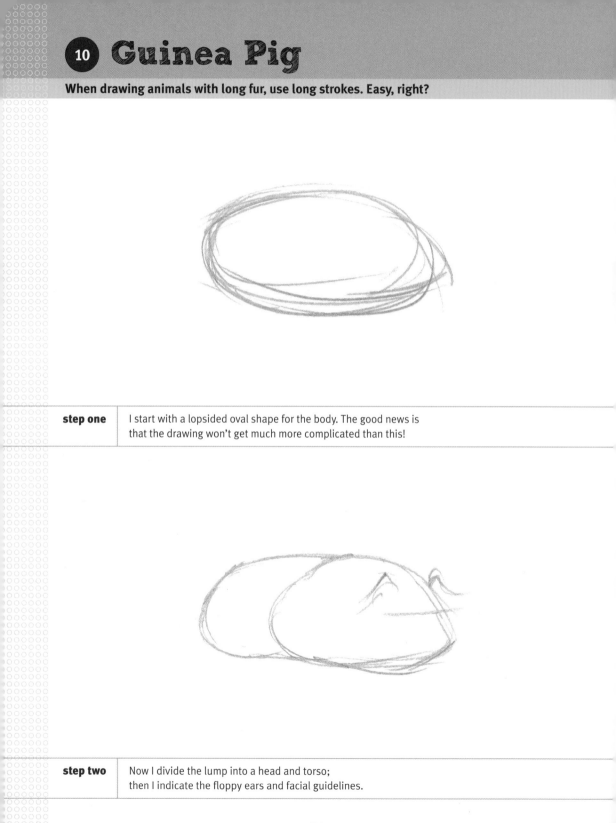

| **step one** | I start with a lopsided oval shape for the body. The good news is that the drawing won't get much more complicated than this! |

| **step two** | Now I divide the lump into a head and torso; then I indicate the floppy ears and facial guidelines. |

| **step three** | I block in the eyes and nose, develop the ears, and add the small claws. Then I start indicating the fur with long, sweeping lines. |

| **step four** | Our drawing is already looking like a guinea pig, so I clean up the lines, add more fur, and draw the front claws. |

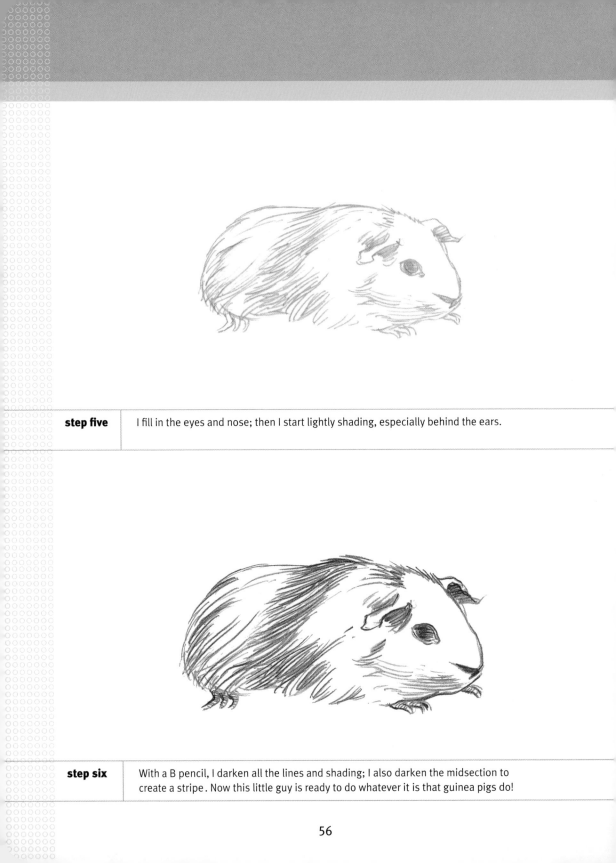

| **step five** | I fill in the eyes and nose; then I start lightly shading, especially behind the ears. |

| **step six** | With a B pencil, I darken all the lines and shading; I also darken the midsection to create a stripe. Now this little guy is ready to do whatever it is that guinea pigs do! |

TIP

You don't need to draw every detail you see.

11 Cocker Spaniel

These happy little dogs seem to bark incessantly, but they're still so lovable.

| **step one** | I start by drawing the basic shapes of the dog with an H pencil. |

| **step two** | I add the teardrop-shaped ear, the pointy tail, and the upturned muzzle. When I separate the legs, they look like baggy pants. I also draw the eye. |

step three | Now I start adding fur, using longer zigzag strokes than I did with the dachshund. Next I refine the small nose.

step four | I continue to build up the fur, keeping in mind that this dog is rather shaggy. Then I add the mouth.

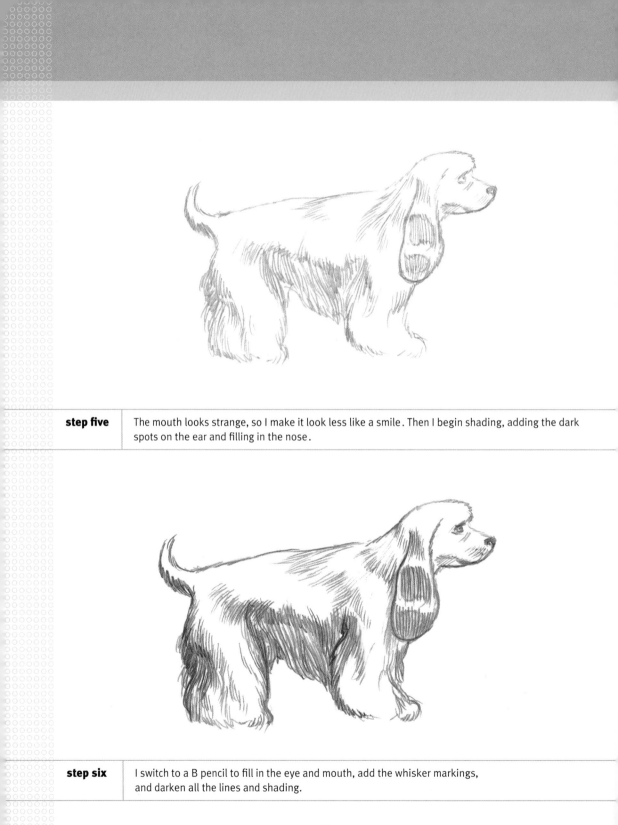

| **step five** | The mouth looks strange, so I make it look less like a smile. Then I begin shading, adding the dark spots on the ear and filling in the nose. |

| **step six** | I switch to a B pencil to fill in the eye and mouth, add the whisker markings, and darken all the lines and shading. |

TIP

With the endless
variety of mixed
and purebred
dogs, your
work with these
animals will never
be complete.

⑫ Female Portrait

Drawing portraits of people from photos can be helpful.
Like animals, they don't usually stay still long.

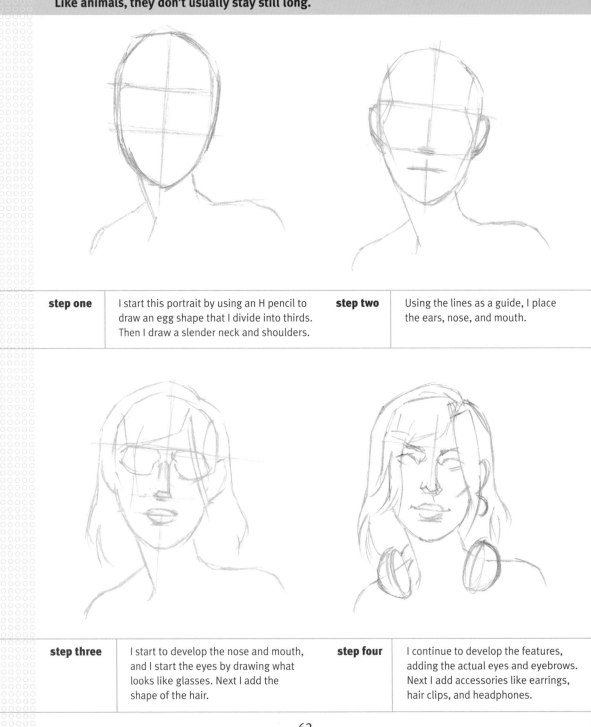

step one	I start this portrait by using an H pencil to draw an egg shape that I divide into thirds. Then I draw a slender neck and shoulders.	**step two**	Using the lines as a guide, I place the ears, nose, and mouth.
step three	I start to develop the nose and mouth, and I start the eyes by drawing what looks like glasses. Next I add the shape of the hair.	**step four**	I continue to develop the features, adding the actual eyes and eyebrows. Next I add accessories like earrings, hair clips, and headphones.

step five	Now I add the pupils and sculpt the nose and lips.
	I also draw more of the hair and add the cord of the headphones.

step six	I fill in the pupils, leaving a highlight in each, and then I start shading.
	I leave her bangs mostly white to show that they're dyed blonde.

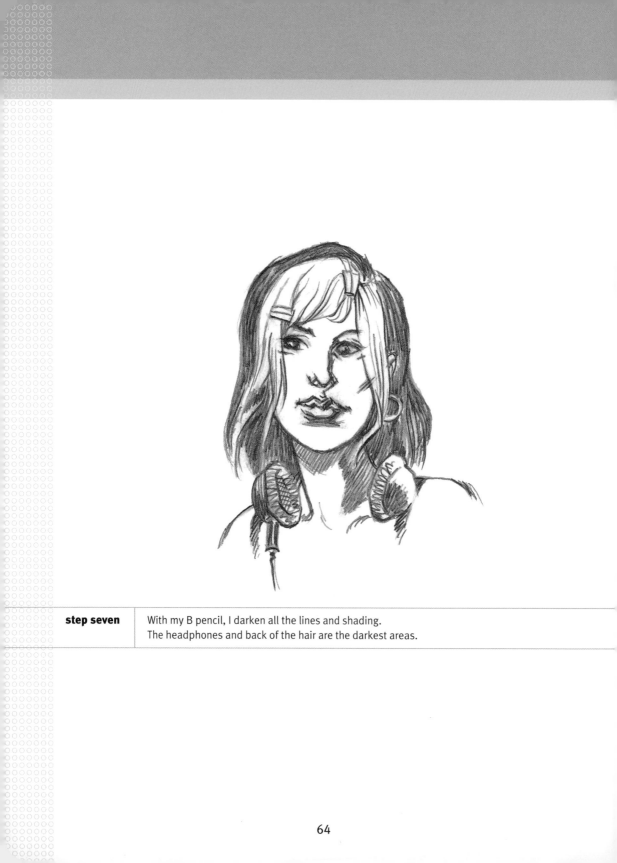

step seven | With my B pencil, I darken all the lines and shading.
The headphones and back of the hair are the darkest areas.

TIP

Dividing the face in thirds horizontally enables you to obtain the correct proportions.

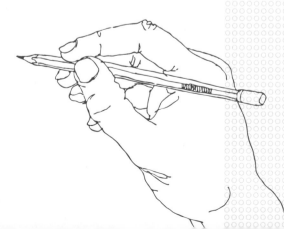

Want to make a friend happy? Make him look like James Dean when you draw him!

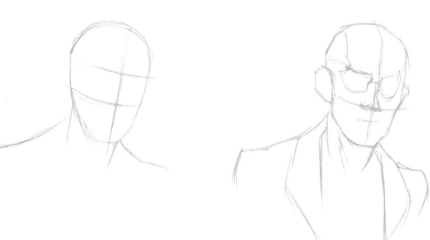

step one As with the female portrait, I start with an oval and divide it into sections. Note that the guidelines are slightly curved because the head is at a three-quarter angle. Next I draw the broad neck and shoulders.

step two I use the guidelines to place the eyes, nose, and mouth. Then I add the ears (the one on the right is barely visible) and the jacket.

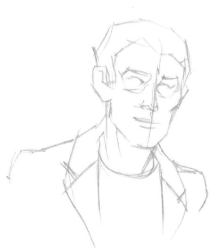

step three I start refining the features, adding the eyebrows and lips. Then I draw the shape of the hair. I also draw the collar of the T-shirt and develop more of the jacket.

| **step four** | I continue to develop the features and add details, cleaning up my lines as I go. |

| **step five** | Now I fill in the pupils and block out the light and dark areas on the figure. This fella is starting to come to life! |

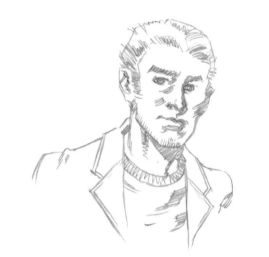

| **step six** | Using step five as a guide, I begin shading, adding details like the ribbing on the shirt collar and the seams of the lapel. Then I draw some scruffy stubble on his chin. |

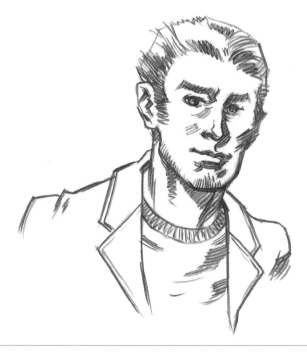

| **step seven** | I switch to a B pencil and darken all my lines and shading, especially under the jaw and on the neck. |

TIP

The mouth is usually closer to the nose than to the chin.

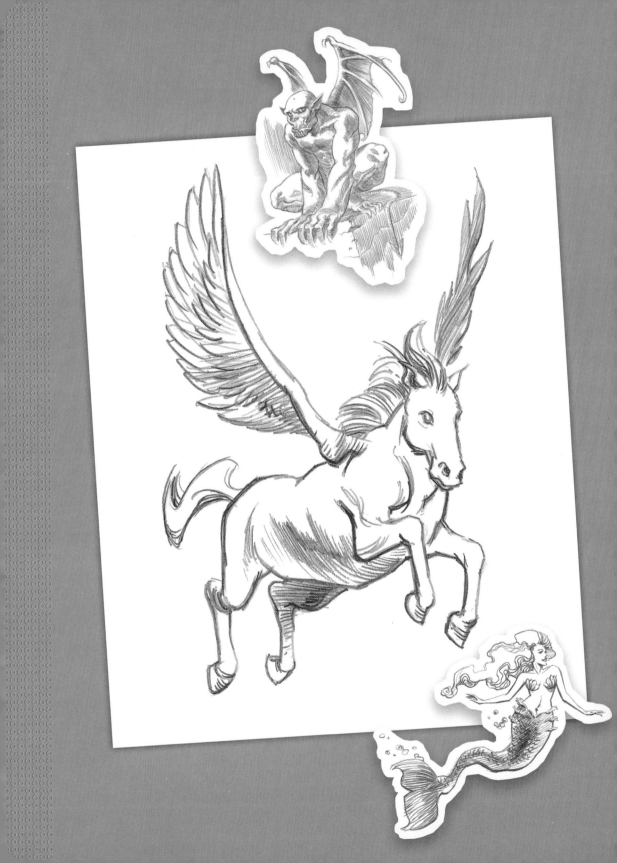

CHAPTER 2

Fantasy Creatures

Come on, stop pretending that you didn't play Dungeons and Dragons in high school (or last night, for that matter).

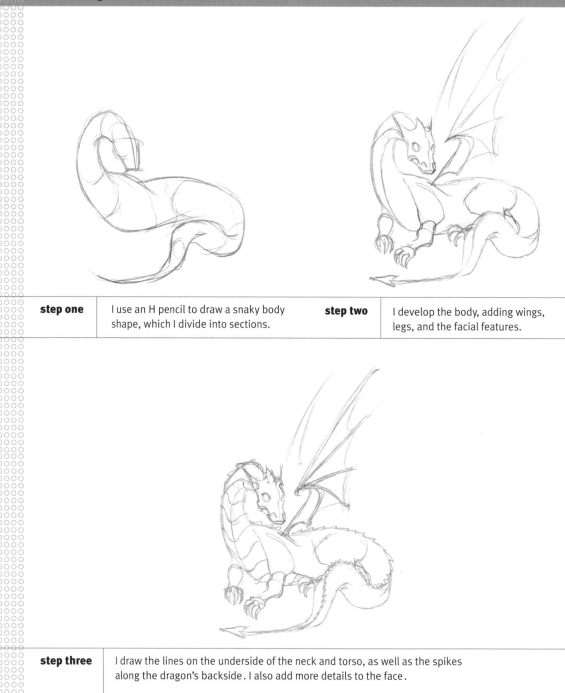

step one	I use an H pencil to draw a snaky body shape, which I divide into sections.

step two	I develop the body, adding wings, legs, and the facial features.

step three	I draw the lines on the underside of the neck and torso, as well as the spikes along the dragon's backside. I also add more details to the face.

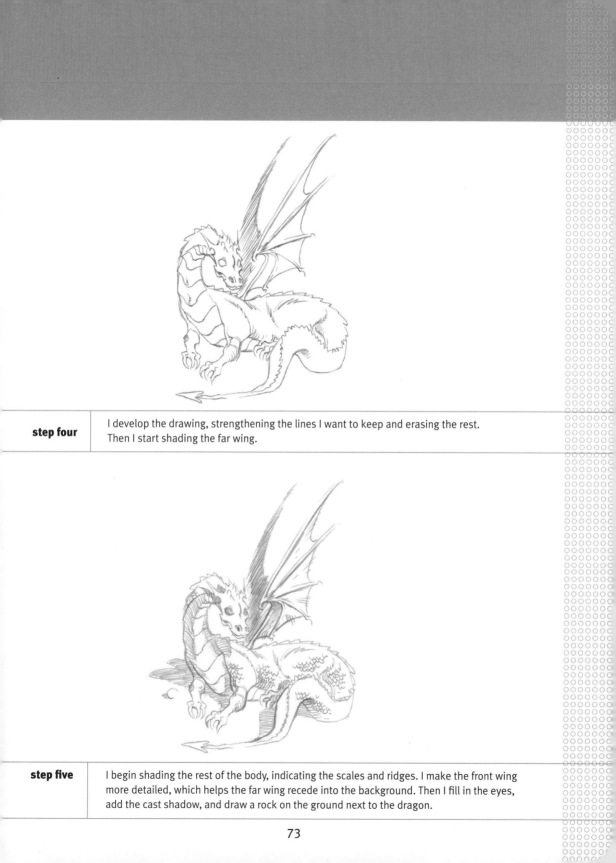

| **step four** | I develop the drawing, strengthening the lines I want to keep and erasing the rest. Then I start shading the far wing. |

| **step five** | I begin shading the rest of the body, indicating the scales and ridges. I make the front wing more detailed, which helps the far wing recede into the background. Then I fill in the eyes, add the cast shadow, and draw a rock on the ground next to the dragon. |

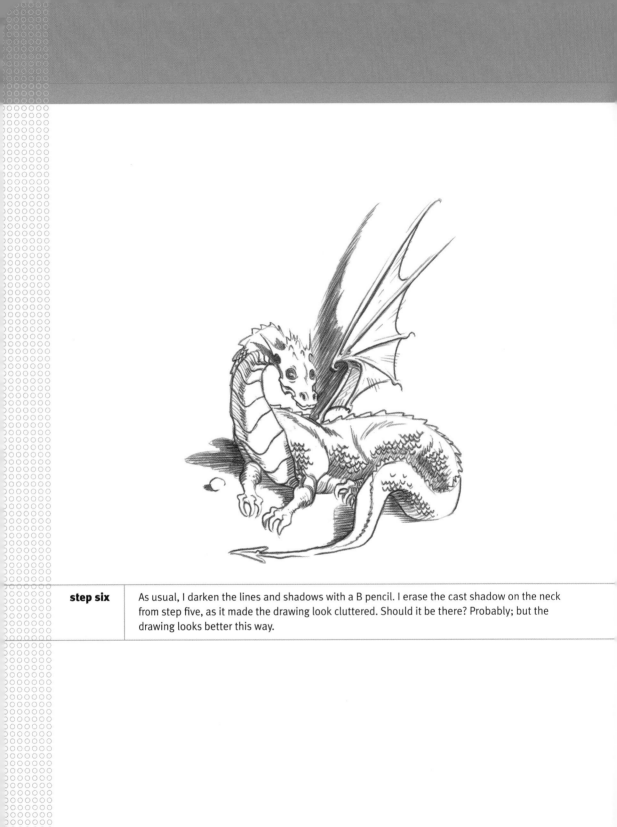

| **step six** | As usual, I darken the lines and shadows with a B pencil. I erase the cast shadow on the neck from step five, as it made the drawing look cluttered. Should it be there? Probably; but the drawing looks better this way. |

TIP

Build darkness
by shading in
layers—the
more layers
you apply, the
darker the area
becomes.

Mermaid

Mermaids may be glamorous, but beware! In some folklore, they were thought to be unlucky omens.

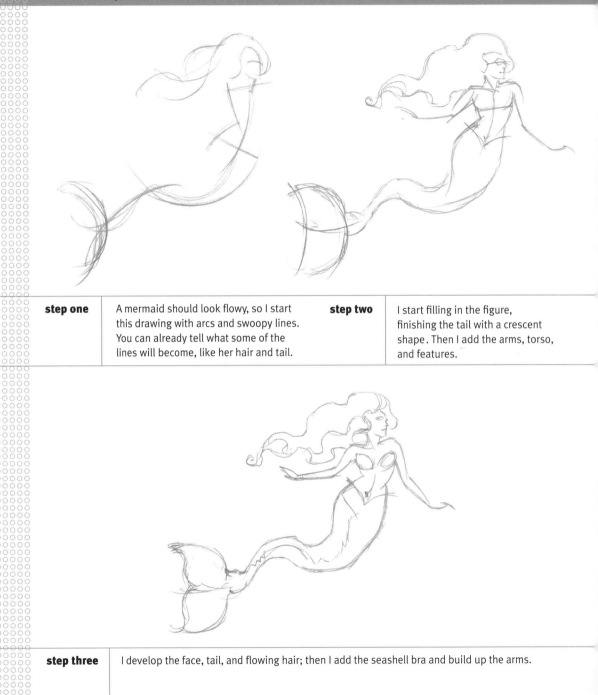

step one A mermaid should look flowy, so I start this drawing with arcs and swoopy lines. You can already tell what some of the lines will become, like her hair and tail.

step two I start filling in the figure, finishing the tail with a crescent shape. Then I add the arms, torso, and features.

step three I develop the face, tail, and flowing hair; then I add the seashell bra and build up the arms.

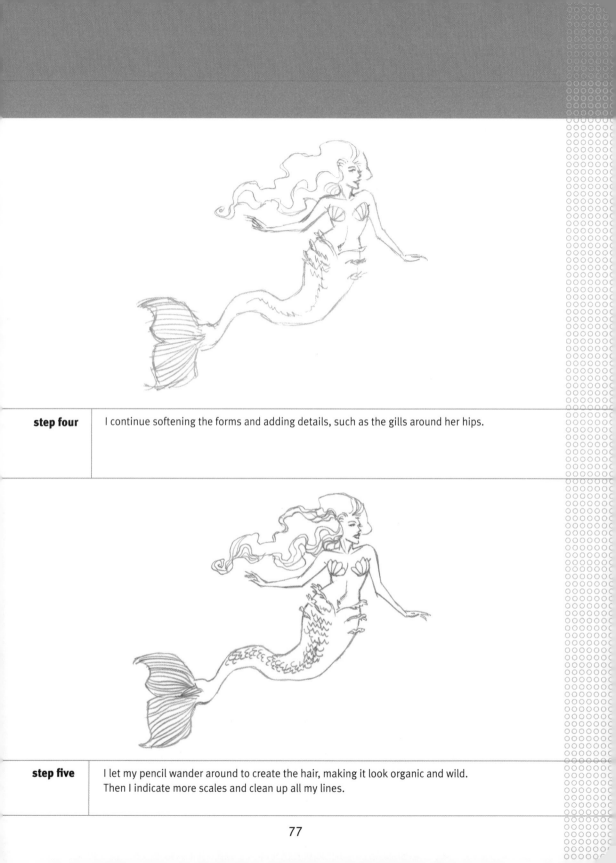

| **step four** | I continue softening the forms and adding details, such as the gills around her hips. |

| **step five** | I let my pencil wander around to create the hair, making it look organic and wild. Then I indicate more scales and clean up all my lines. |

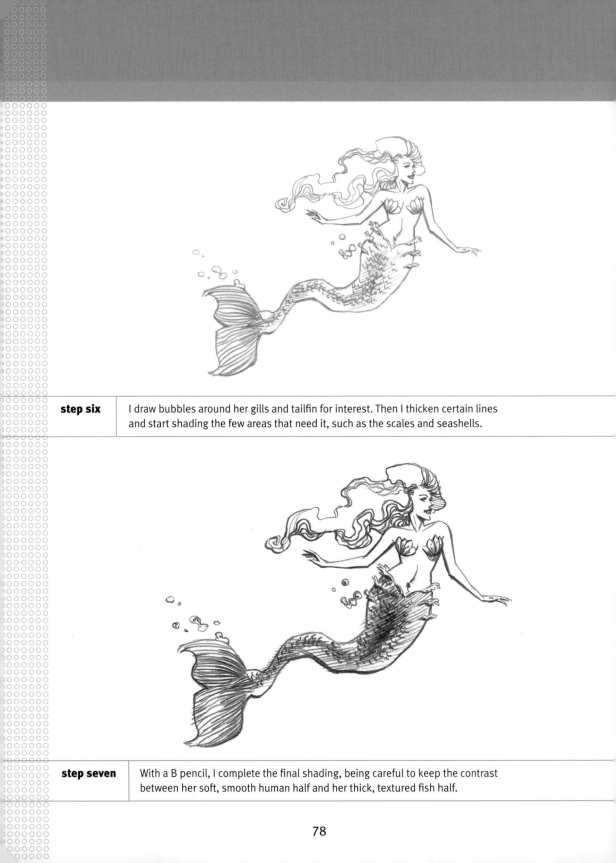

| **step six** | I draw bubbles around her gills and tailfin for interest. Then I thicken certain lines and start shading the few areas that need it, such as the scales and seashells. |

| **step seven** | With a B pencil, I complete the final shading, being careful to keep the contrast between her soft, smooth human half and her thick, textured fish half. |

TIP

To get inspiration
for your creature's
scales study real
life examples of
scales, such as
snakes and fish.

16 Gargoyle

Despite their ghoulish appearance, most gargoyles aren't bad guys; their ugly mugs actually ward off evil spirits!

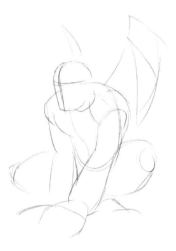

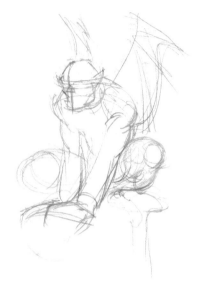

| **step one** | I use an H pencil to sketch this crouching mythological beast, adding facial guidelines for placement. | **step two** | I use the guides to block in the facial features, and I rough in the forms of the body and wings. I also add a tail that hangs off a ledge. |

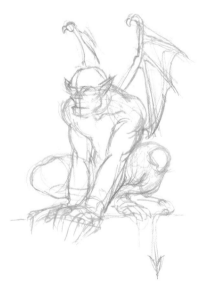

| **step three** | I continue to flesh out the figure, making it look muscular. Then I detail the wings, hands, feet, and tail. Note the claws on the tips of the wings. |

| **step four** | I develop the face, shading it to look sunken. Then I start shading the wings and body. I lengthen the top bone of the wing at right and add more sharp claws. |

| **step five** | I shade and refine the gargoyle further, filling in the pupils and shading the ledge on which he perches. |

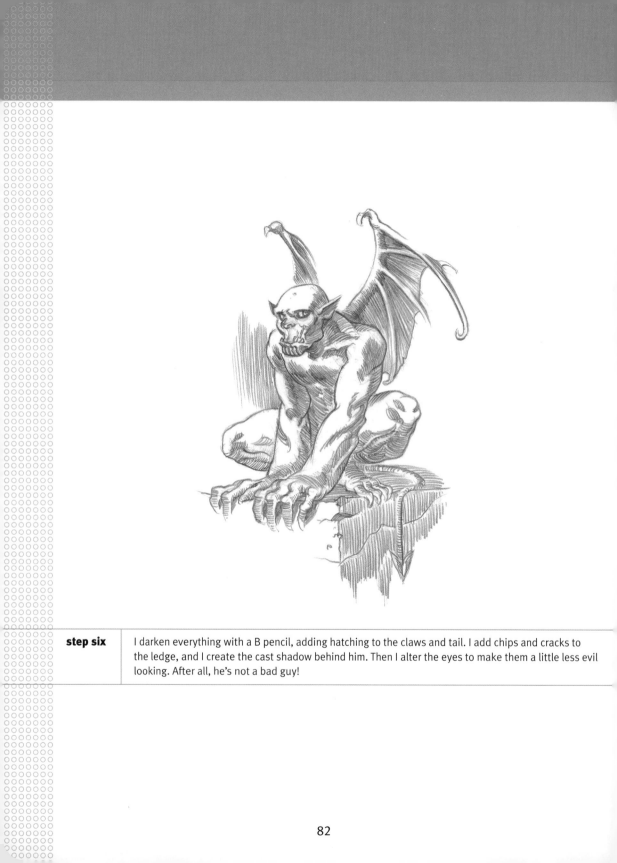

step six I darken everything with a B pencil, adding hatching to the claws and tail. I add chips and cracks to the ledge, and I create the cast shadow behind him. Then I alter the eyes to make them a little less evil looking. After all, he's not a bad guy!

TIP

The eyes are one of the most important features for conveying emotion.

It's a bird! It's a plane! It's...a horse with wings!

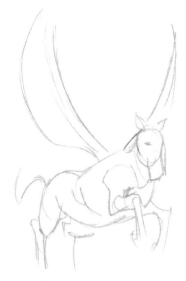

step one | I start by drawing the torso and head of a horse with B pencil; then I suggest the arched legs.

step two | I build up the general forms, including the legs, tail, and ears. Then I add the wings, and it's a Pegasus!

step three | I continue fleshing out the forms, adding details such as the eyes, nostrils, and hooves. I make the mane and tail flowy to suggest motion.

step four | Now I clean up my lines and create the individual feathers of the wings. I also add more hair to the mane.

step five | I start lightly shading, mostly making sure that the far wing doesn't look like it's growing out of the Pegasus's head.

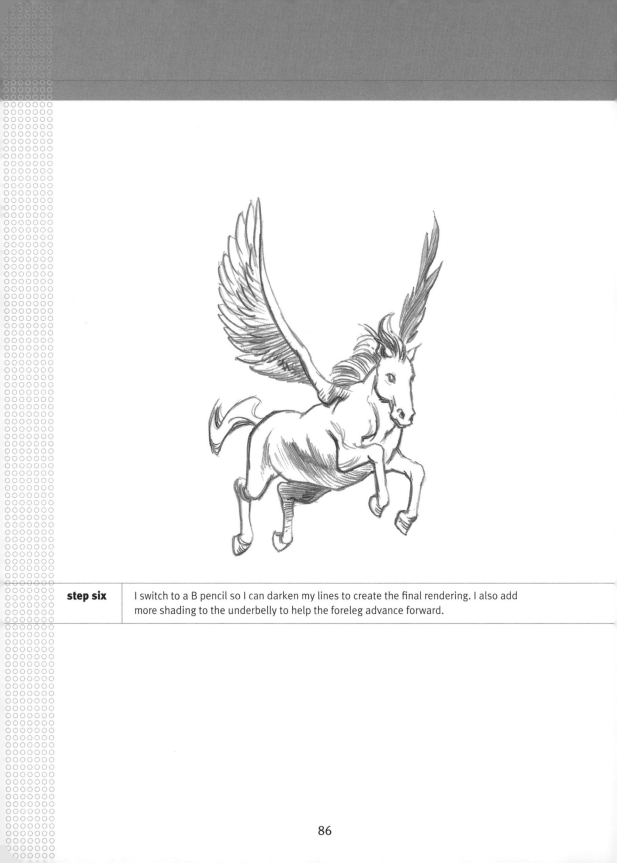

| **step six** | I switch to a B pencil so I can darken my lines to create the final rendering. I also add more shading to the underbelly to help the foreleg advance forward. |

TIP

Reference photos
of humans and
animals with
features similar
to the fantasy
creature you are
drawing.

Pixies aren't always all sugar and spice and everything nice—let's draw an eerie-looking one.

step one For this little mischief maker, I use an H pencil to sketch the pose of the figure.

step two Now I construct what looks like a mannequin over the sketch. I also block in the shapes of the wings and add facial guidelines.

step three Using the facial guidelines, I block in the eyes, nose, mouth, and ears. I refine the shapes, defining the clawlike fingers and indicating her outfit. Note that the wings look like curled leaves.

step four I decide to turn the head so it faces the viewer, so I make the necessary adjustments. Then I continue refining the forms. I also draw the hair (complete with a flower) and detail the outfit.

| **step five** | Now I clean up my lines, strengthening those I like and want to keep. I also indicate some light shading. |

| **step six** | I continue shading, making the hair dark but leaving a band of white to suggest a headband. I also add leaflike veins to the wings. Then I fill in the eyes, making them seem otherworldly. I also shade the back leg to make it more distant. |

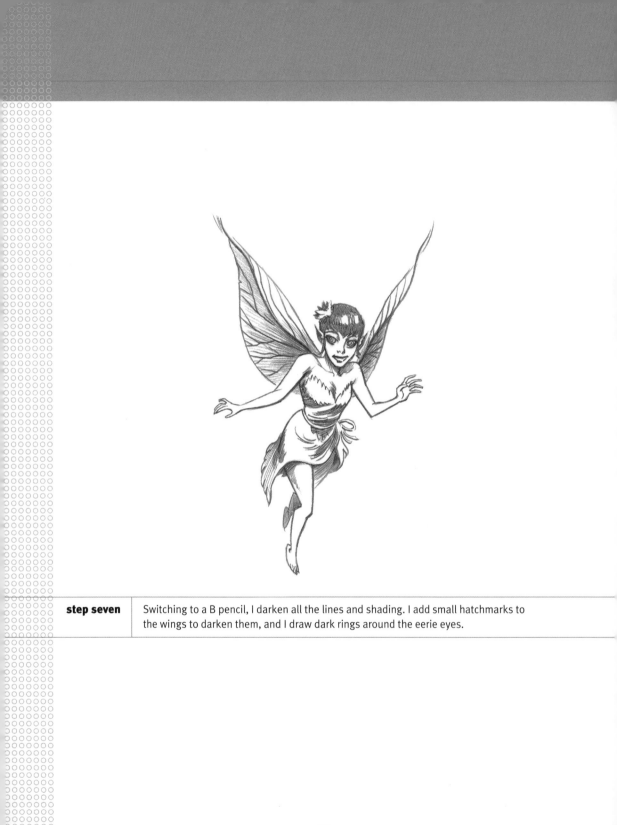

step seven | Switching to a B pencil, I darken all the lines and shading. I add small hatchmarks to the wings to darken them, and I draw dark rings around the eerie eyes.

TIP

Your creature's
wings can be
drawn to express
its thoughts and
emotions.

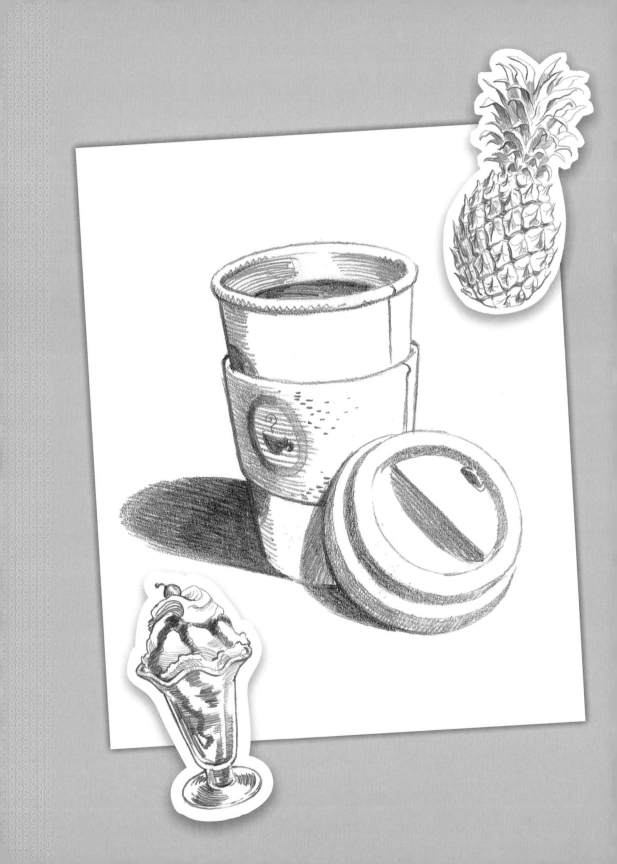

Food and Drink

Apples are not only packed with vitamins A and C, but also lessons on shapes, shading, and light.

step one	I start this drawing by blocking in the basic shape with an H pencil.

step two	I indicate the plane of the top of the apple and the pit that slopes into the stem, as well as the cast shadow.

| **step three** | Now I refine the shapes and clean up my lines. I also add quick strokes to the front of the apple for the form shadow. |

| **step four** | I start to fill in the values using hatchmarks. I use curved lines on the lighter right side. |

| **step five** | I continue shading, leaving a white highlight. Then I darken the stem. |

| **step six** | Switching to a B pencil, I deepen the shading, making the darkest areas the left side of the apple and the cast shadow. |

TIP

Shiny objects
have sharp-edged
highlights. Dull
or soft-textured
highlights have
soft-edged,
blurred highlights.

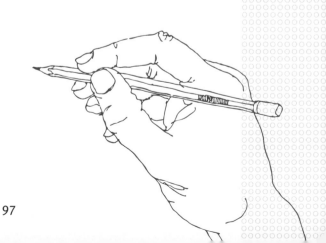

Next time you crave fries, try drawing them instead of heading for the drive-through!

step one	I start by using an H pencil to draw a box for the…well, the box. Then I add the general shape of the fries.

step two	Using the general shape as a guide, I draw individual fries and round the edges of the box. Then I start the box's logo.

step three | Now I define the fries, giving them shape and form. I make them turn in different directions so they look more natural. Then I continue refining the box and logo.

step four | I clean up my lines and shade the hamburger patty on the logo. I also add a long highlight on the right side of the box to indicate the shiny material.

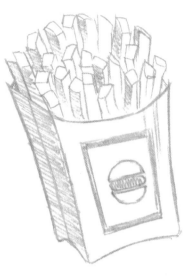

step five | I begin shading the left side of most of the fries, being careful not to overdo it. I also shade the left side of the box and fill in the border on the logo.

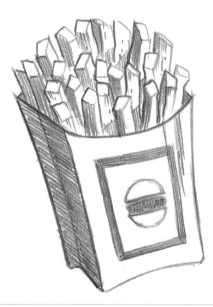

step six | As usual, I switch to a B pencil and darken everything. I add a few spots of tone to some of the fries to make them look more realistic. You can almost taste the salty goodness.

TIP

Begin drawing
simple subjects
to build-up your
confidence.

21 Martini

When drawing a martini, it never hurts to add a few olives. Cheers!

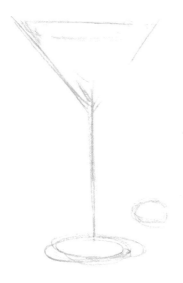

| **step one** | I start this martini by using an H pencil to draw an upside-down triangle on a stick. I use ovals for the base and olive. |

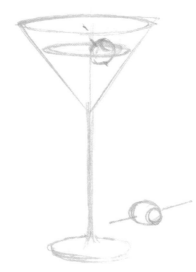

| **step two** | I start refining the shapes, drawing the liquid and an olive on a toothpick inside the glass. |

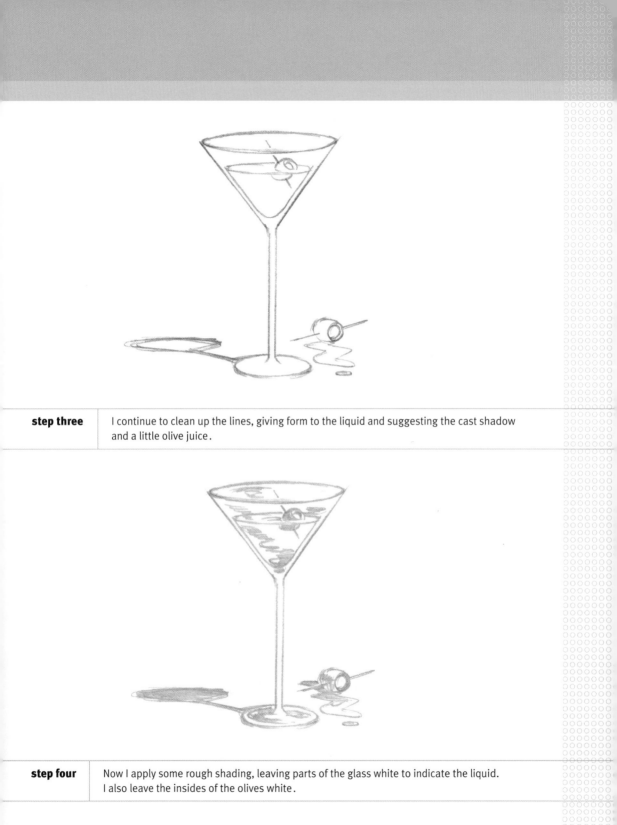

step three I continue to clean up the lines, giving form to the liquid and suggesting the cast shadow and a little olive juice.

step four Now I apply some rough shading, leaving parts of the glass white to indicate the liquid. I also leave the insides of the olives white.

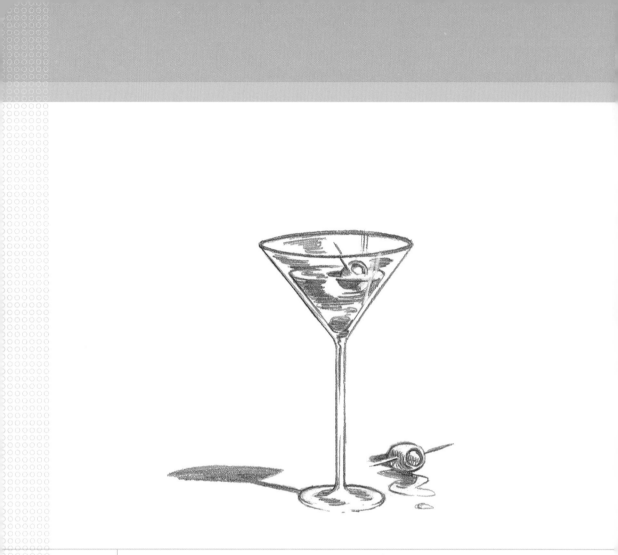

step five With a B pencil, I darken the shading and outlines. Then I drag the eraser over the glass to indicate a reflective surface. Bottoms up!

TIP

To lighten the
tone in shading,
decrease the
pressure on the
pencil.

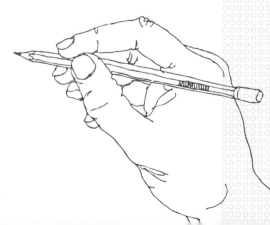

22 Pineapple

Despite its spiky surface, this fruit is used as a symbol to welcome people in some cultures.

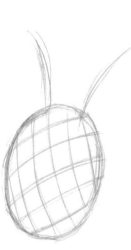

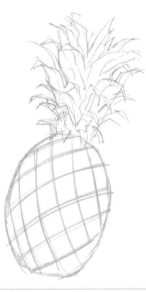

step one	With an H pencil, I draw an oval for the pineapple and add two curved lines for the shape of the leaves. Then I draw a criss-cross pattern that curves around the form of the pineapple.

step two	I draw the leaves, making them smaller and more condensed at the base and wider and longer at the top.

step three	Using the lines as a guide, I create the diamond shapes. Rounding off the edges gives the shapes form and makes them appear three-dimensional.

| **step four** | Now I add spikes to each diamond shape, making sure they point upward. |

| **step five** | I start shading the undersides of the leaves and spikes, as well as the spaces between each diamond shape. |

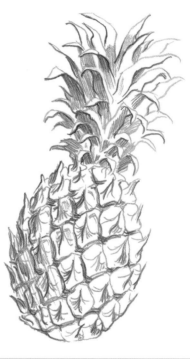

step six | Using a B pencil, I darken the shading, emphasizing the grooves between the shapes and darkening the left side of the pineapple.

TIP

Practice drawing
other fruits and
vegetables,
focusing on the
varied textures,
and patterns of
their seeds, pulp,
and skins.

Nothing will wake you up in the morning like drawing a nice, hot cup of java!

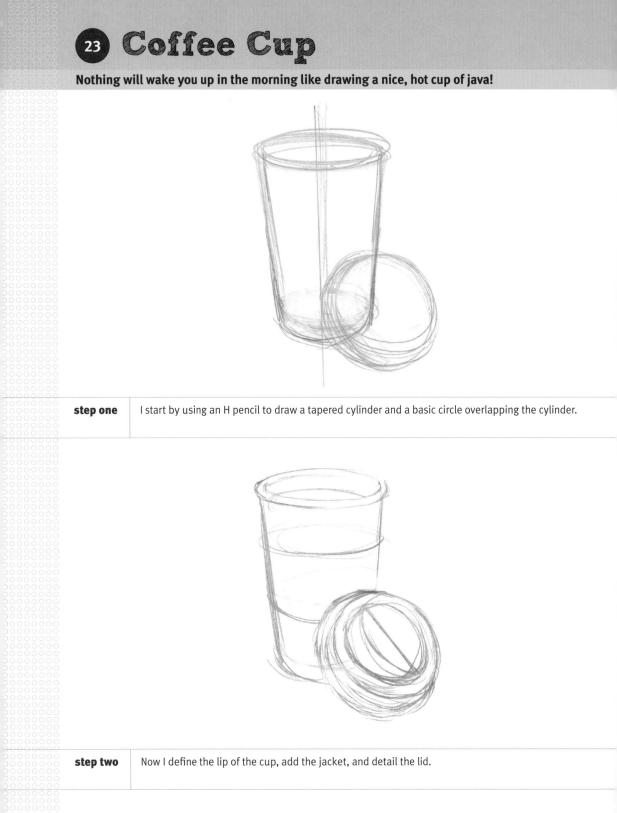

| **step one** | I start by using an H pencil to draw a tapered cylinder and a basic circle overlapping the cylinder. |

| **step two** | Now I define the lip of the cup, add the jacket, and detail the lid. |

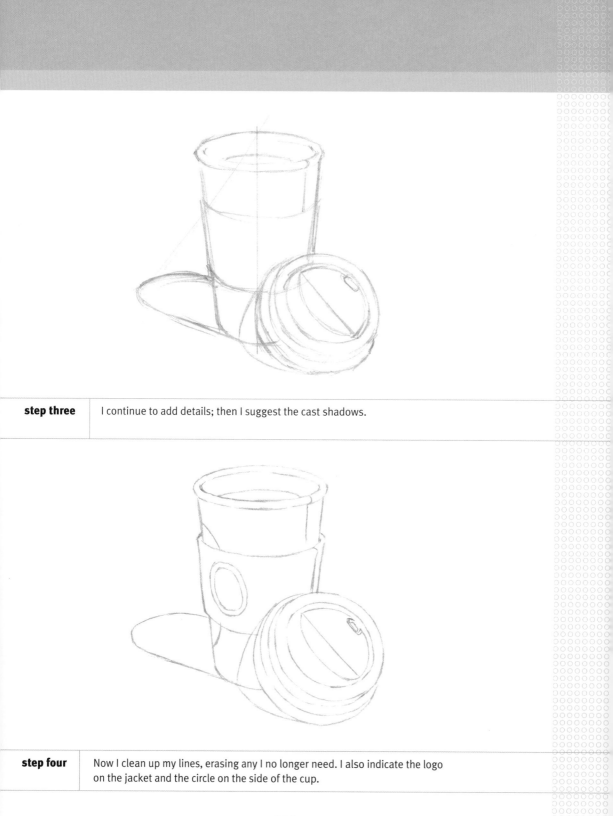

step three | I continue to add details; then I suggest the cast shadows.

step four | Now I clean up my lines, erasing any I no longer need. I also indicate the logo on the jacket and the circle on the side of the cup.

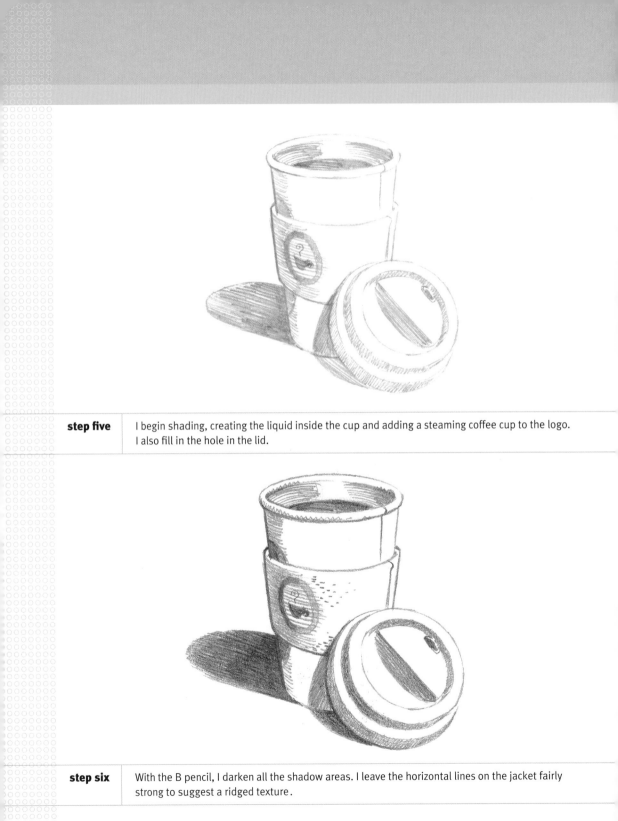

step five I begin shading, creating the liquid inside the cup and adding a steaming coffee cup to the logo. I also fill in the hole in the lid.

step six With the B pencil, I darken all the shadow areas. I leave the horizontal lines on the jacket fairly strong to suggest a ridged texture.

TIP

Explore how the
different pencil
points can yield
varying tones
from light to dark.

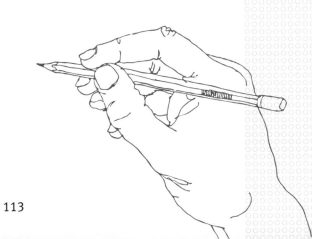

Draw me! Pretty please? With a cherry on top?

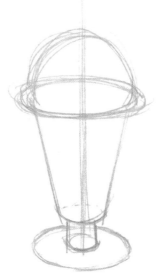

step one	I use an H pencil and basic shapes to start this drawing, which looks kind of space-agey at this stage.

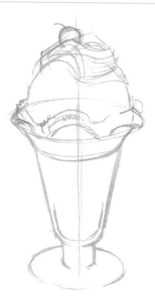

step two	I refine the shape of the glass, adding a fancy curved edge. Then I indicate the blob of whipped cream and the cherry.

step three I continue developing the forms, adding streams of fudge on the ice cream and wavy lines on the glass to indicate a reflective surface.

step four I add more details to the glass and start shading the fudge so I don't get confused. Note that you can see some of the fudge through the glass. I also refine the cherry stem.

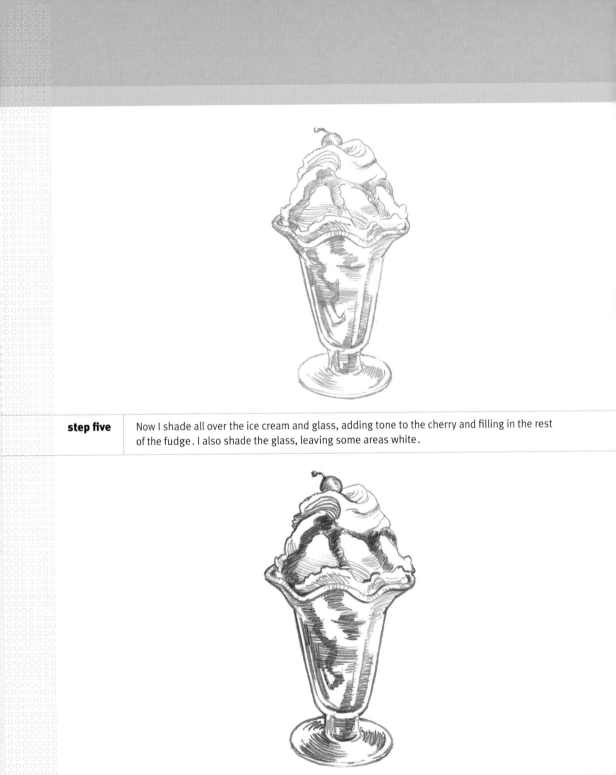

| **step five** | Now I shade all over the ice cream and glass, adding tone to the cherry and filling in the rest of the fudge. I also shade the glass, leaving some areas white. |

| **step six** | I use a B pencil for the final rendering, making the fudge the darkest value and softening the shading on the ice cream. To finish, I erase some areas of the glass to make it look shiny. |

TIP

For highlights,
save the white of
the paper or lift
them out with an
eraser.

Be sure to celebrate after drawing the graceful lines of this traditional Japanese sake set. *Kanpai!*

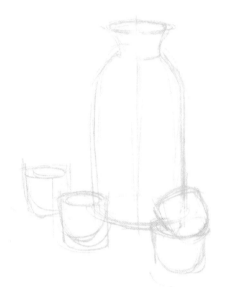

step one	First I block in modified cylinders for the cups and bottle with an H pencil. I add a tilted cup inside another cup for interest.

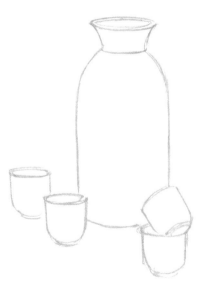

step two	Now I refine the shapes, erasing any unwanted lines.

step three | I add a flowery design to the bottle and cups, adding cast shadows for each.

step four | Now I start lightly shading, adding horizontal lines on the cups and bottle to suggest texture.

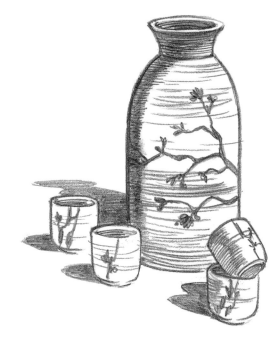

step five | I use a B pencil to darken all the lines and shading; then I add the final details to the cups.

TIP

Fine detail work is
best done with a
sharp pencil held
as though you
were writing.

This drawing will take you on a trip down memory lane...

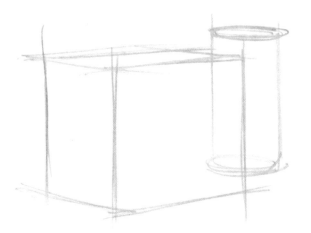

| **step one** | I use an H pencil to draw a basic box and a cylinder for the thermos. |

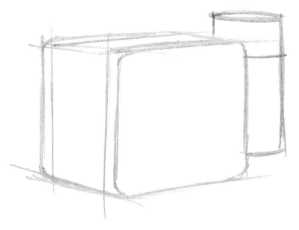

| **step two** | I develop the shapes, rounding off the corners and defining the lids. |

step three | Now I add both handles and a border for the front of the lunchbox. What good is a lunchbox without a fun picture on the front?

step four | I decide to go with a Hawaiian theme, so I draw a palm tree, some waves, lines for the sky, and the sun.

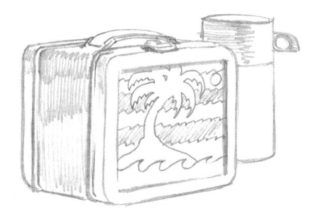

step five | After cleaning up my lines, I start shading the sides and back of the lunchbox, as well as the lid and handle of the thermos.

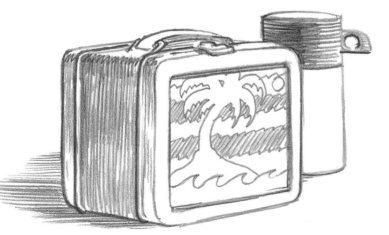

step six | Switching to a B pencil, I darken all the lines and shading. I keep the shading on the side of the lunchbox irregular to give it a metallic feel.

TIP

For smoother
shading,
gradually build
it up with light
pressure on the
pencil tip.

A fine bottle of wine—always a vintage subject for an artist.

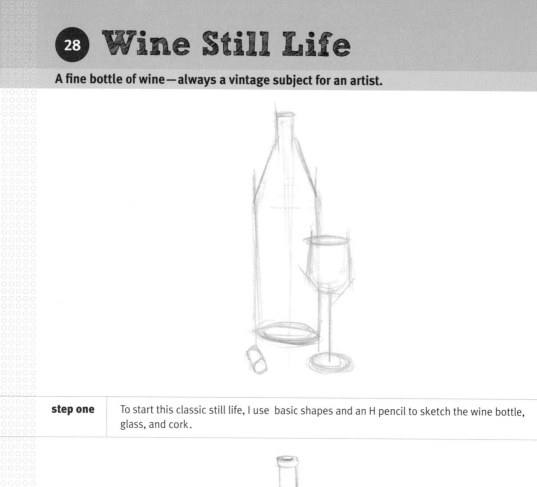

step one	To start this classic still life, I use basic shapes and an H pencil to sketch the wine bottle, glass, and cork.

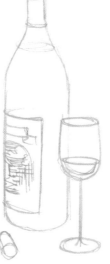

step two	I develop the shapes, erasing unneeded lines as I go. I suggest the liquid in both glasses and block in the wine label.

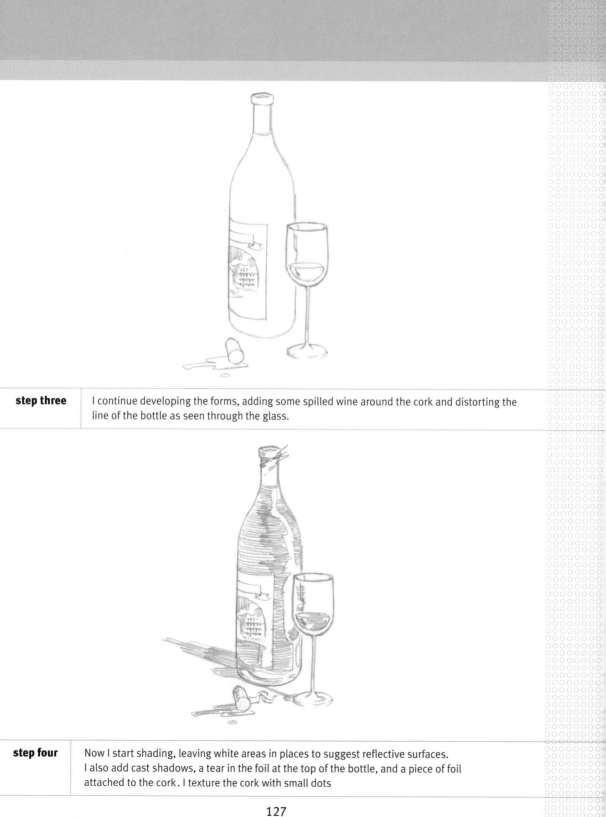

step three | I continue developing the forms, adding some spilled wine around the cork and distorting the line of the bottle as seen through the glass.

step four | Now I start shading, leaving white areas in places to suggest reflective surfaces. I also add cast shadows, a tear in the foil at the top of the bottle, and a piece of foil attached to the cork. I texture the cork with small dots

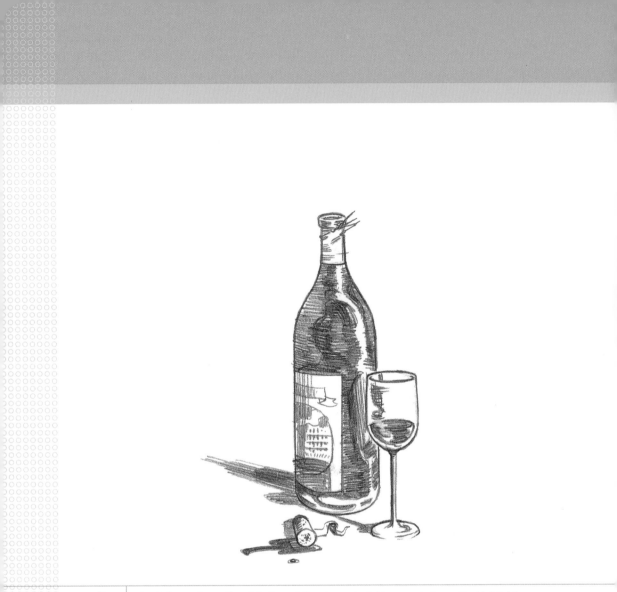

| **step five** | I switch to a B pencil and darken all the elements, taking care to leave the highlights as white as possible. |

TIP

Patterns and
textures can
add interest to
an otherwise
ordinary subject.

Did you know that "sushi" actually refers to the rice itself? Let's draw a plate of tasty rolls.

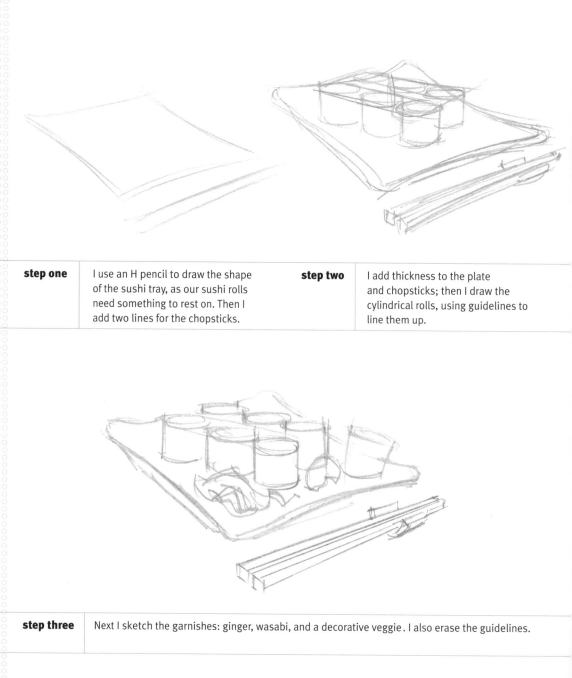

step one I use an H pencil to draw the shape of the sushi tray, as our sushi rolls need something to rest on. Then I add two lines for the chopsticks.

step two I add thickness to the plate and chopsticks; then I draw the cylindrical rolls, using guidelines to line them up.

step three Next I sketch the garnishes: ginger, wasabi, and a decorative veggie. I also erase the guidelines.

step four | I start developing the details, using square shapes for the fish. Spicy tuna, perhaps?

step five | I start indicating the textures of the seaweed and rice, erasing guidelines as I refine the outlines. I also add shading to the inside corner of the plate.

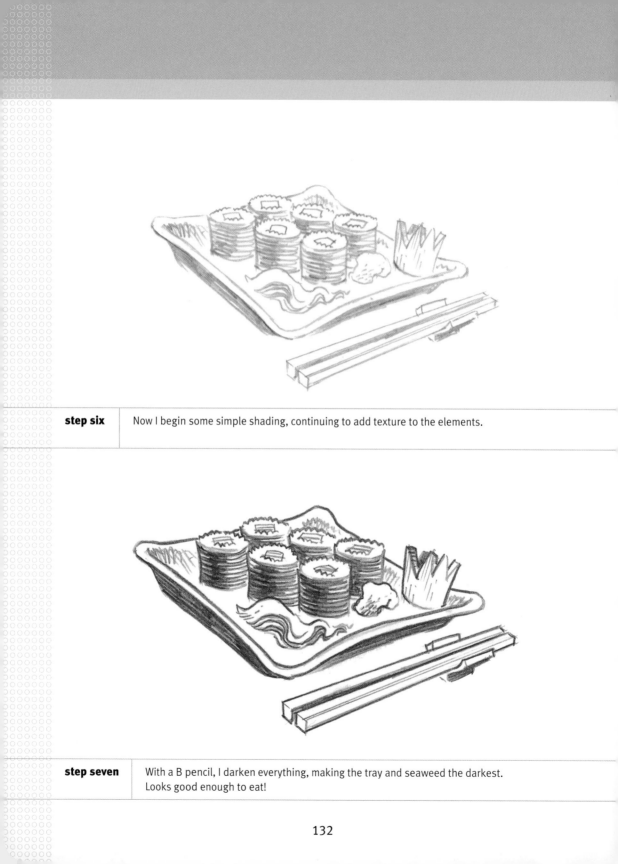

step six | Now I begin some simple shading, continuing to add texture to the elements.

step seven | With a B pencil, I darken everything, making the tray and seaweed the darkest.
Looks good enough to eat!

132

TIP

All edges are
not created equal
and should not
be drawn that way
unless you want
a coloring book
look.

133

Still Lifes and Other Objects

The perfect plant is a drawing of one: No water necessary!

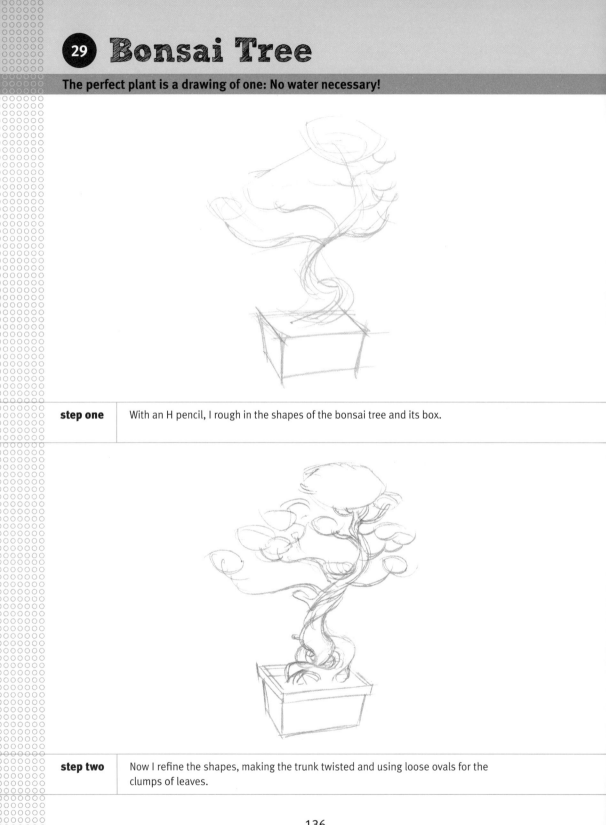

step one	With an H pencil, I rough in the shapes of the bonsai tree and its box.

step two	Now I refine the shapes, making the trunk twisted and using loose ovals for the clumps of leaves.

| **step three** | I tighten up the lines a bit and draw a little flower design on the box. I also add short strokes for the leaf texture. |

| **step four** | Now I start shading, creating the foliage and the texture of the box. I also add more twisty lines to the trunk. |

step five | Switching to a B pencil, I darken all the shadows. Note that I leave the tops of the leaves white to indicate the light source.

TIP

Paper texture
matters. Smooth
paper is good
for fine details.
Rough texture is
good for coarse
surfaces.

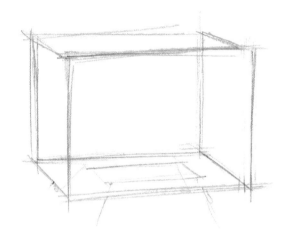

step one	To draw this boob tube, I use an H pencil to draw a simple box in perspective; then I throw on some legs.

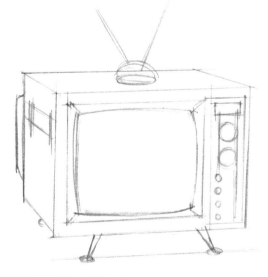

step two	I add some rough details (screen, knobs, buttons, antennae, and the like), using a ruler to make straight lines.

step three | I continue to add details and then clean up my lines with an eraser.

step four | Now I start lightly shading, indicating the rounded screen and the cast shadow.

step five | I use a B pencil to darken and tighten up all my lines. On the screen, I darken the lines as they get farther from the light source.

TIP

Keep your style consistent throughout your drawing.

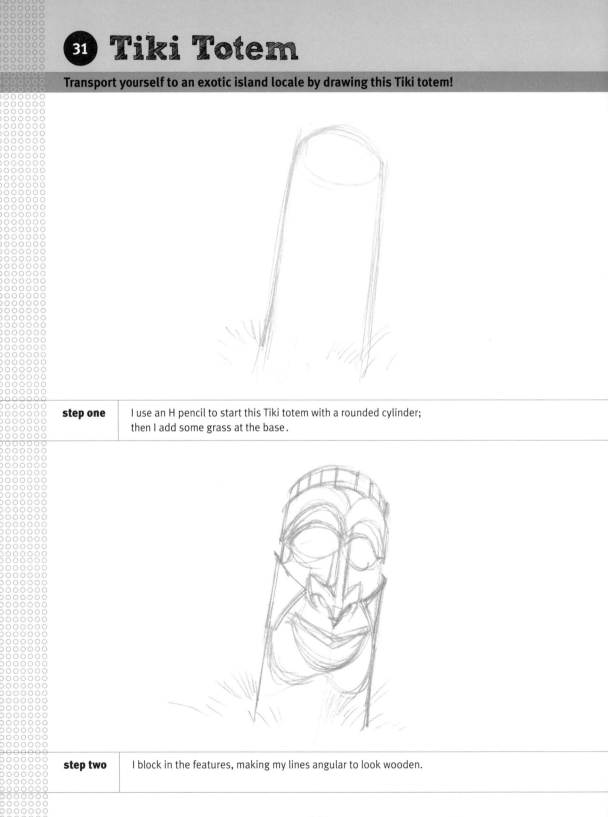

31 Tiki Totem

Transport yourself to an exotic island locale by drawing this Tiki totem!

step one	I use an H pencil to start this Tiki totem with a rounded cylinder; then I add some grass at the base.

step two	I block in the features, making my lines angular to look wooden.

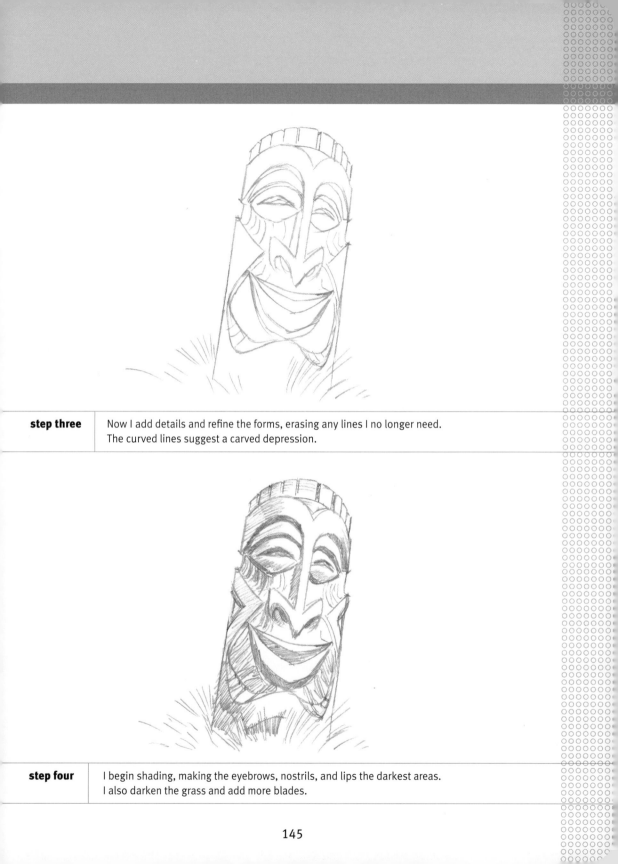

step three Now I add details and refine the forms, erasing any lines I no longer need. The curved lines suggest a carved depression.

step four I begin shading, making the eyebrows, nostrils, and lips the darkest areas. I also darken the grass and add more blades.

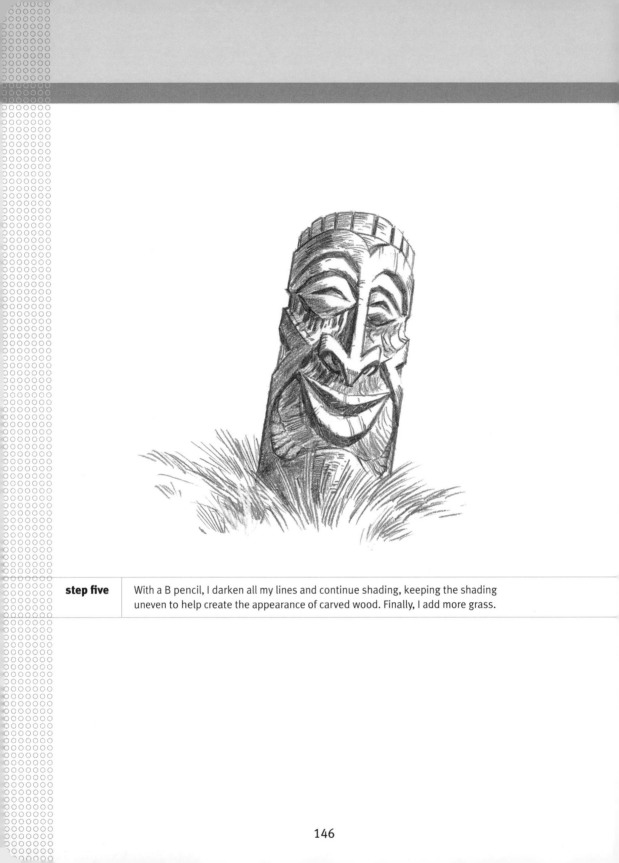

step five With a B pencil, I darken all my lines and continue shading, keeping the shading uneven to help create the appearance of carved wood. Finally, I add more grass.

TIP

Collect pictures
of subjects that
interest you.

The next best thing to owning a scooter is drawing one, right?

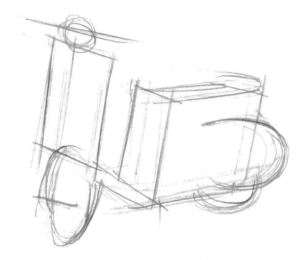

| **step one** | I use an H pencil and basic shapes to block in the scooter. |

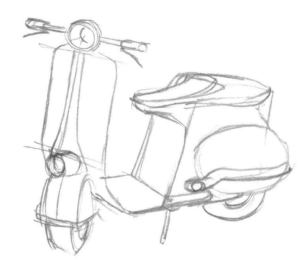

| **step two** | Now I add the handlebars, seat, light, kickstand, and wheels. |

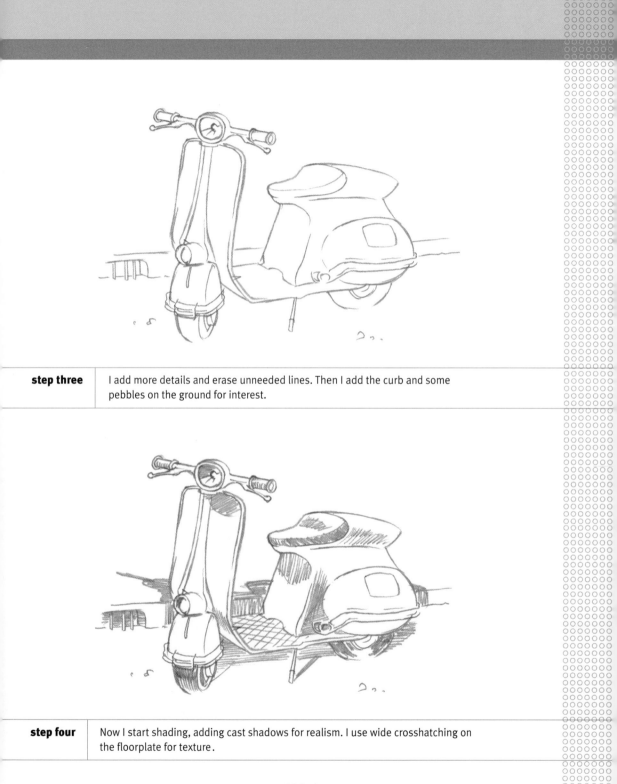

step three | I add more details and erase unneeded lines. Then I add the curb and some pebbles on the ground for interest.

step four | Now I start shading, adding cast shadows for realism. I use wide crosshatching on the floorplate for texture.

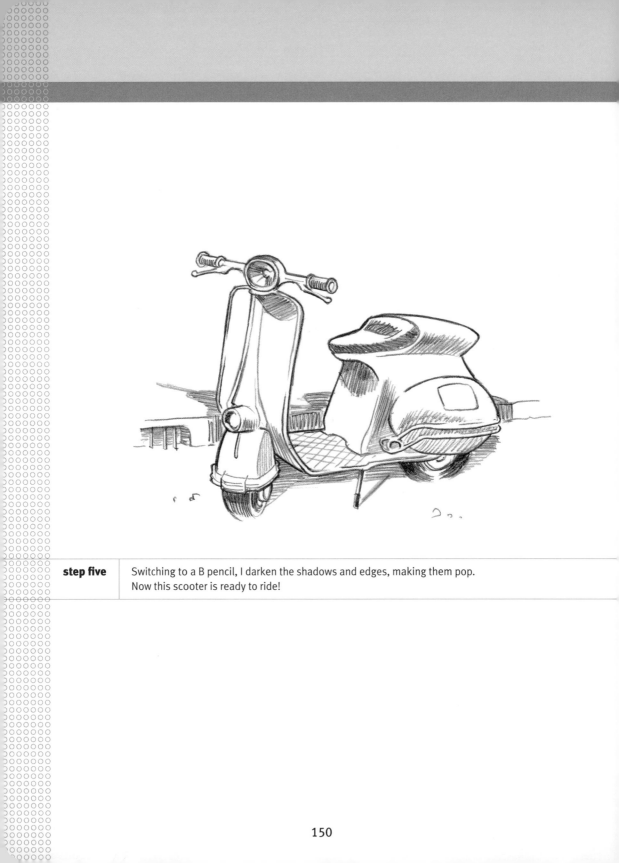

step five | Switching to a B pencil, I darken the shadows and edges, making them pop. Now this scooter is ready to ride!

TIP

Round points on
pencils are good
for shading.

33 Retro Clock

Use a ruler to make straight lines in your drawings. Don't worry, it's not cheating!

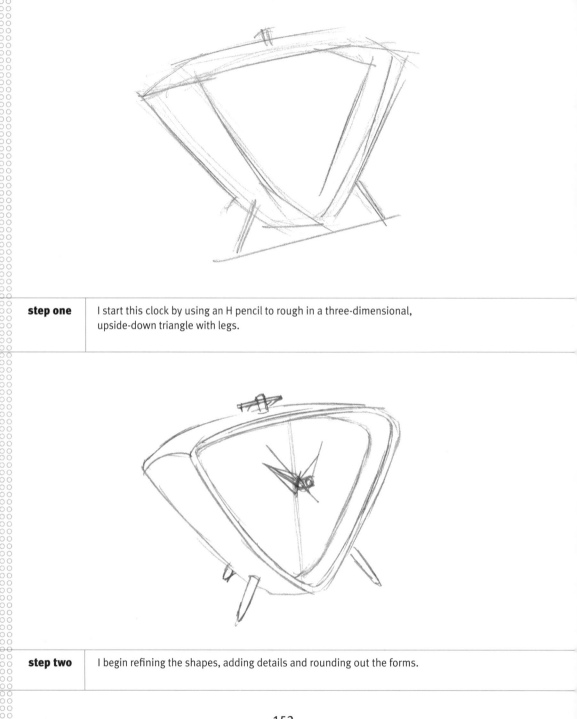

step one I start this clock by using an H pencil to rough in a three-dimensional, upside-down triangle with legs.

step two I begin refining the shapes, adding details and rounding out the forms.

step three	Using a ruler, I divide the clock into 12 parts and add the numbers. Then I roughly sketch the pinup girl. I make the numbers on the left side only partially visible to show depth.

step four	I refine the shape of the girl and carefully clean up all my guidelines.

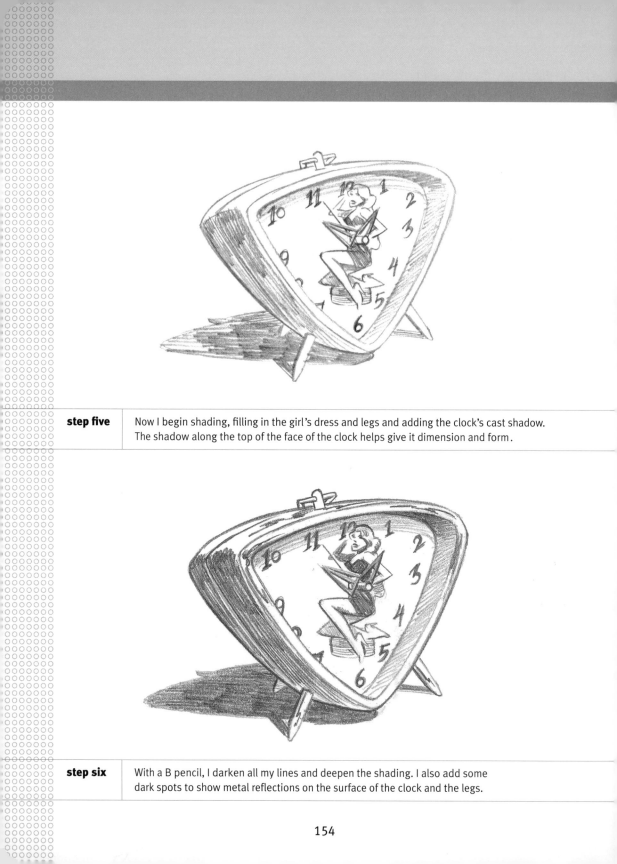

step five Now I begin shading, filling in the girl's dress and legs and adding the clock's cast shadow. The shadow along the top of the face of the clock helps give it dimension and form.

step six With a B pencil, I darken all my lines and deepen the shading. I also add some dark spots to show metal reflections on the surface of the clock and the legs.

TIP

Combine objects that don't seem related to create a unique still life.

You've seen him in lawns everywhere, but have you ever drawn this ubiquitous gnome? Here's your chance!

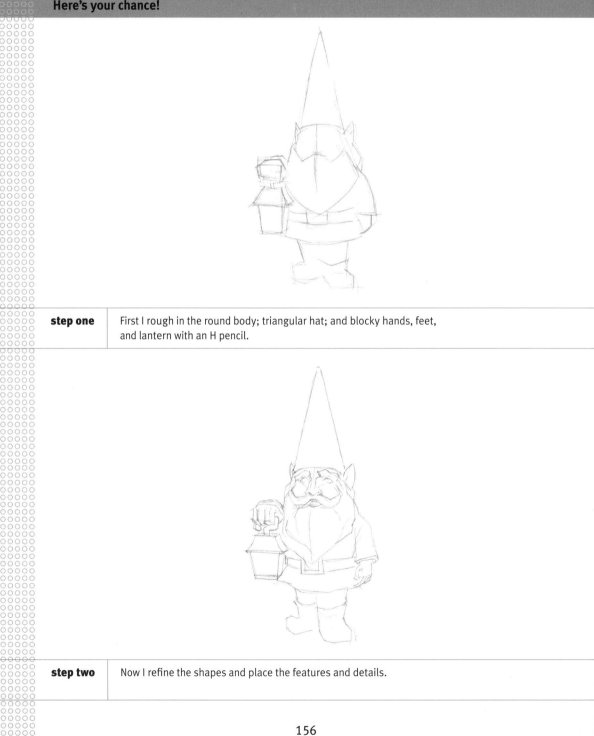

step one	First I rough in the round body; triangular hat; and blocky hands, feet, and lantern with an H pencil.

step two	Now I refine the shapes and place the features and details.

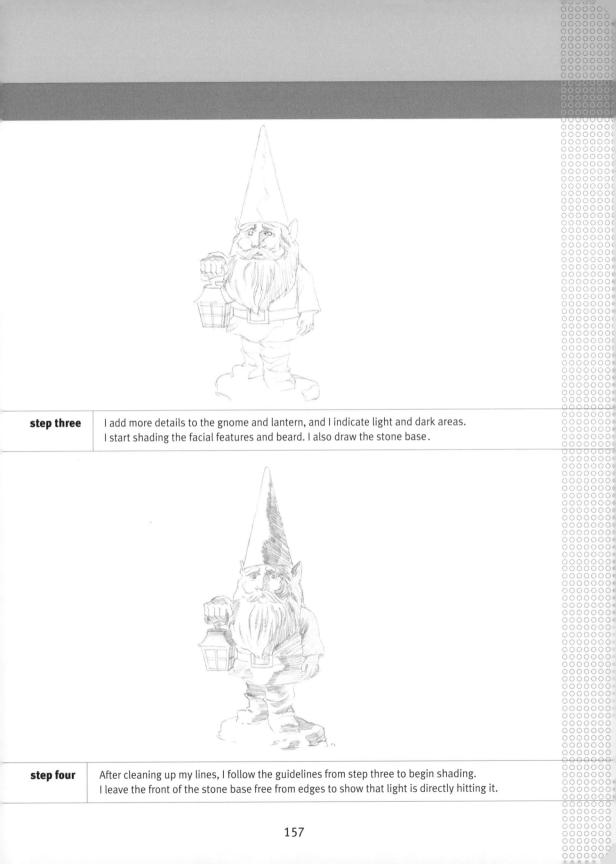

step three | I add more details to the gnome and lantern, and I indicate light and dark areas.
I start shading the facial features and beard. I also draw the stone base.

step four | After cleaning up my lines, I follow the guidelines from step three to begin shading.
I leave the front of the stone base free from edges to show that light is directly hitting it.

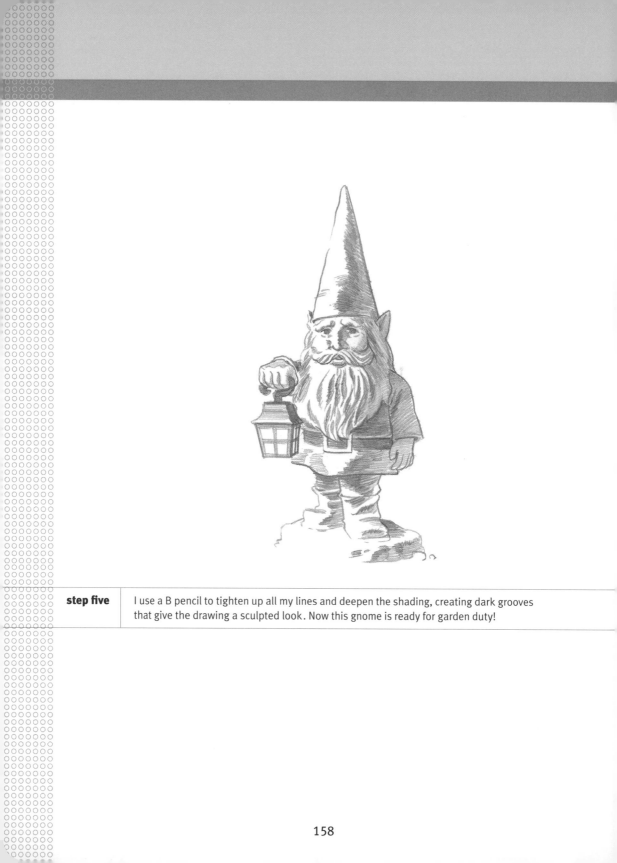

step five I use a B pencil to tighten up all my lines and deepen the shading, creating dark grooves that give the drawing a sculpted look. Now this gnome is ready for garden duty!

TIP

A person's
eyes are rarely
symmetrical.

Here's the ideal pair of shoes: They won't hurt your feet and they'll never wear out.

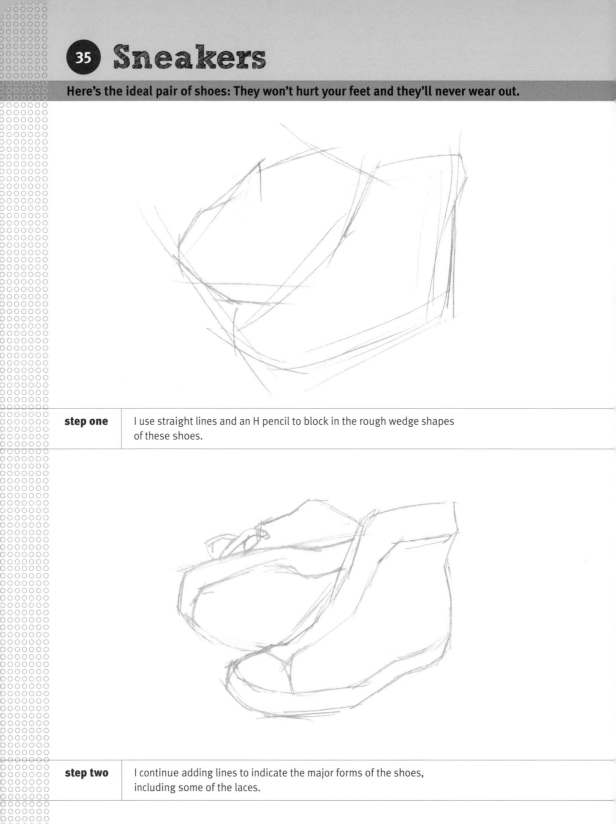

| **step one** | I use straight lines and an H pencil to block in the rough wedge shapes of these shoes. |

| **step two** | I continue adding lines to indicate the major forms of the shoes, including some of the laces. |

| **step three** | I draw more laces, laceholes, and the pattern on the bottom of the shoe. Then I draw a circle for the branding and indicate some folds in the fabric. |

| **step four** | I finish drawing the laces and continue adding details, especially on the rubber soles. |

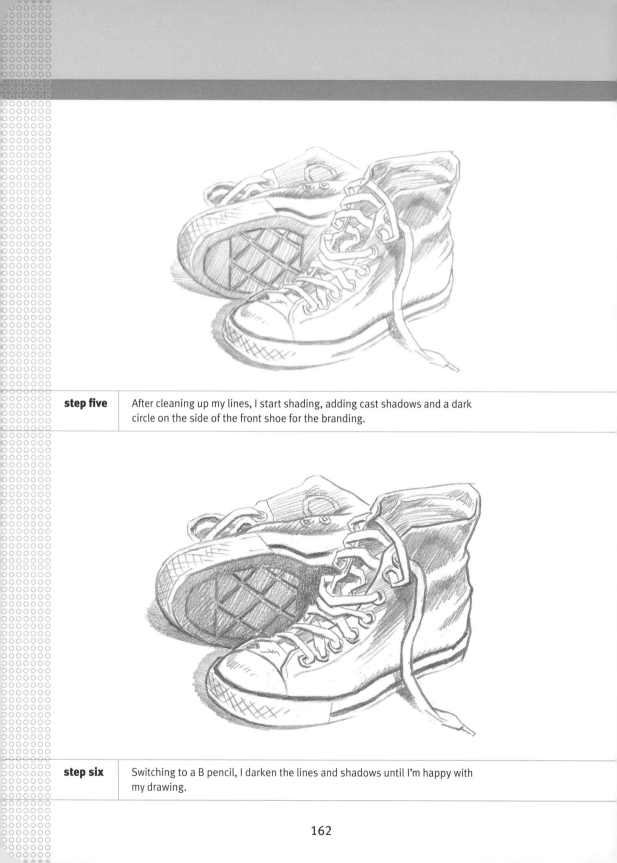

step five | After cleaning up my lines, I start shading, adding cast shadows and a dark circle on the side of the front shoe for the branding.

step six | Switching to a B pencil, I darken the lines and shadows until I'm happy with my drawing.

TIP

Smudging is
important for
creating shading
and gradients.
Use a tortillion,
blending stump,
or chamois cloth
to blend your
strokes.

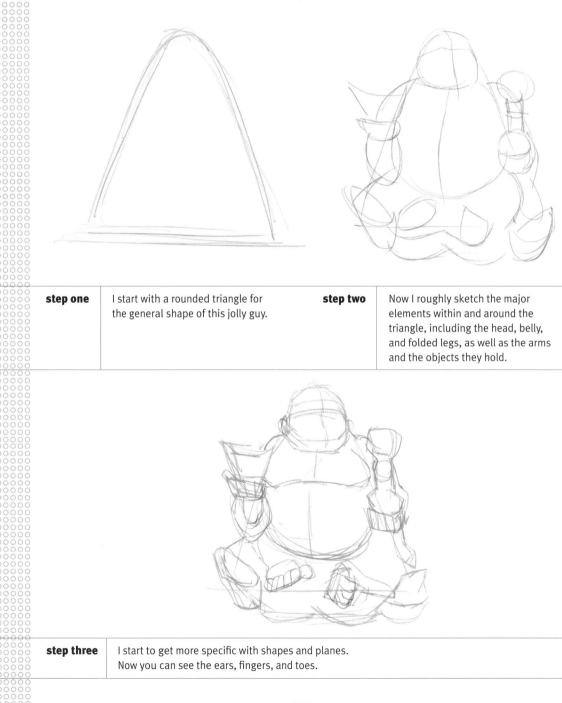

36 Buddha

This statue is known as Budai, or the Laughing Buddha. Hey, I'd be laughing too if I had all those treasures!

step one | I start with a rounded triangle for the general shape of this jolly guy.

step two | Now I roughly sketch the major elements within and around the triangle, including the head, belly, and folded legs, as well as the arms and the objects they hold.

step three | I start to get more specific with shapes and planes. Now you can see the ears, fingers, and toes.

step four	Now I add the facial features, creating the happy expression. Then I refine the fingers and develop the shapes of the objects, such as the necklace. I also add the belly button.

step five	Now I go to town with the details, refining lines and adding shapes. I also indicate the light area on his bulging stomach.

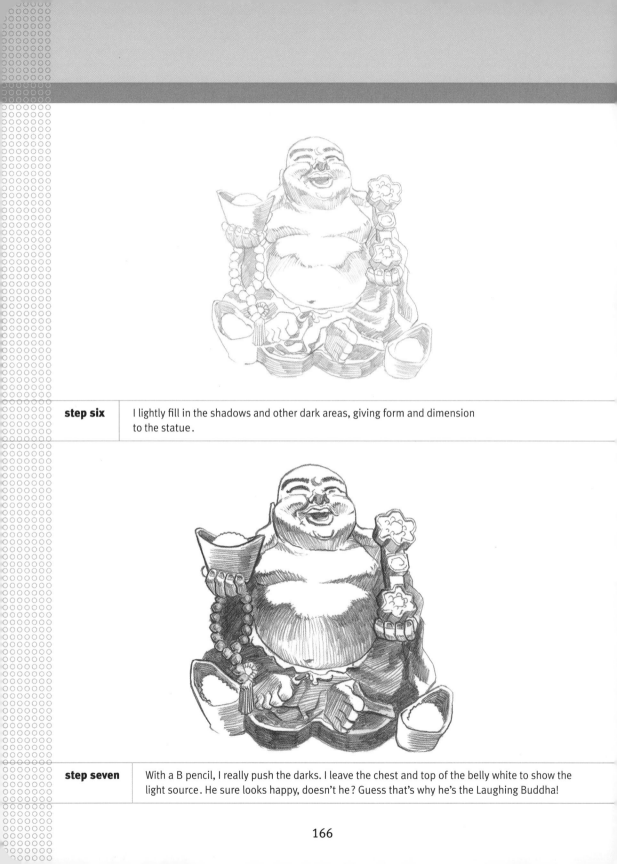

| **step six** | I lightly fill in the shadows and other dark areas, giving form and dimension to the statue. |

| **step seven** | With a B pencil, I really push the darks. I leave the chest and top of the belly white to show the light source. He sure looks happy, doesn't he? Guess that's why he's the Laughing Buddha! |

TIP

A single source of
lighting is best for
still life drawings.

37 Guitar

If you can't play the guitar, don't fret—now you can impress your friends with a drawing of a guitar.

step one | I use an H pencil to draw the number 8 (or a snowman, whichever you prefer). Then I add straight lines for the fretboard (that long neck thing, for those of you who don't speak guitar).

step two | I add form to the base of the guitar and block in the basic parts (the soundhole is the circle and the bridge is the rectangle). I also erase the lines in the neck.

168

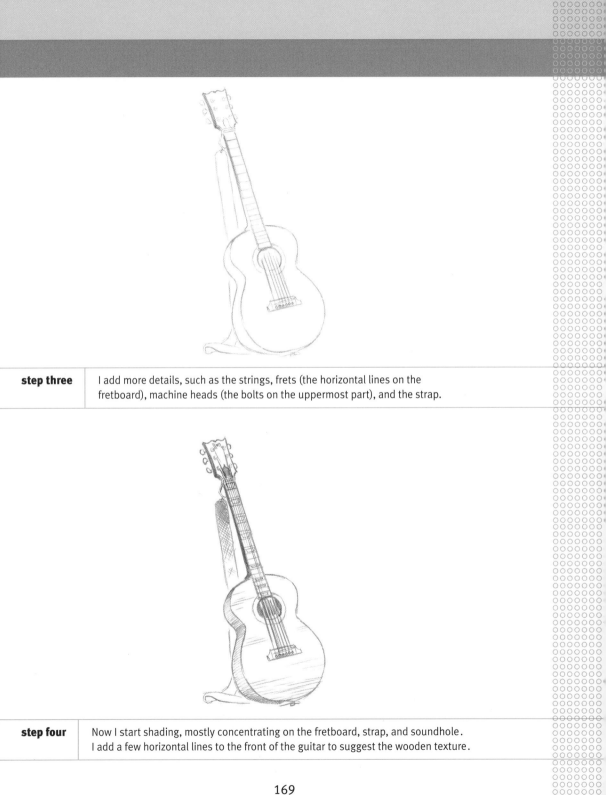

step three | I add more details, such as the strings, frets (the horizontal lines on the fretboard), machine heads (the bolts on the uppermost part), and the strap.

step four | Now I start shading, mostly concentrating on the fretboard, strap, and soundhole. I add a few horizontal lines to the front of the guitar to suggest the wooden texture.

169

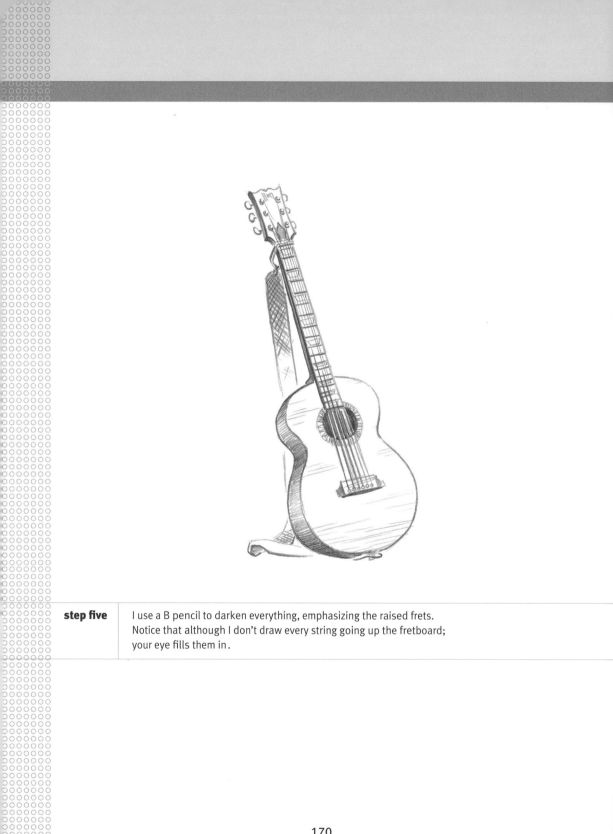

step five | I use a B pencil to darken everything, emphasizing the raised frets.
Notice that although I don't draw every string going up the fretboard;
your eye fills them in.

TIP

Pay attention to
detail to create
a more accurate
rendering.

Maneki Neko

This cat is believed to bring good luck to its owner. Who couldn't use more good luck?

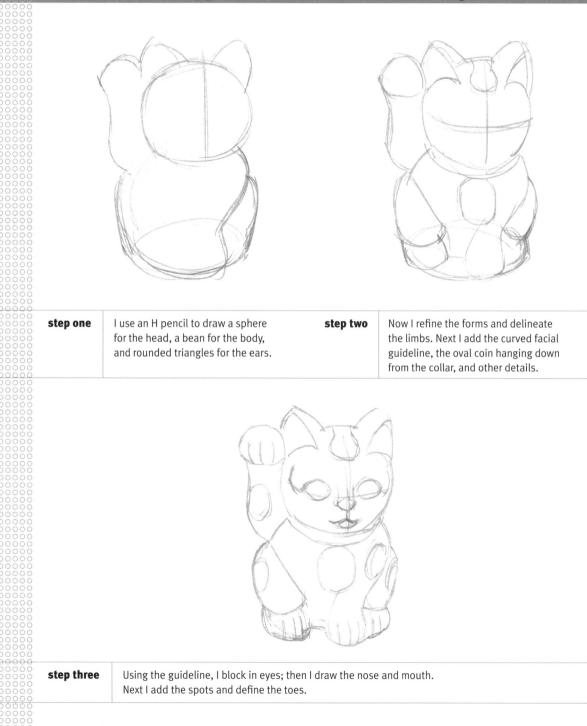

step one I use an H pencil to draw a sphere for the head, a bean for the body, and rounded triangles for the ears.

step two Now I refine the forms and delineate the limbs. Next I add the curved facial guideline, the oval coin hanging down from the collar, and other details.

step three Using the guideline, I block in eyes; then I draw the nose and mouth. Next I add the spots and define the toes.

| **step four** | I continue adding details, such as the triangular claws, round pupils, and lettering on the coin. Then I indicate some of the darker areas. |

| **step five** | I start shading, filling in the spots, ears, and pupils. Note that I leave highlights in the pupils. |

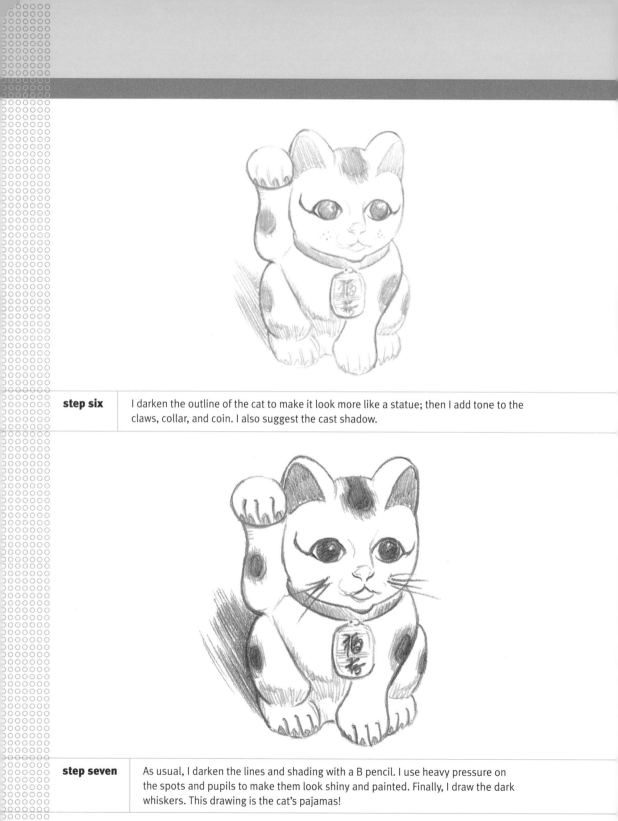

step six

I darken the outline of the cat to make it look more like a statue; then I add tone to the claws, collar, and coin. I also suggest the cast shadow.

step seven

As usual, I darken the lines and shading with a B pencil. I use heavy pressure on the spots and pupils to make them look shiny and painted. Finally, I draw the dark whiskers. This drawing is the cat's pajamas!

TIP

Shadows add
interest to your
drawing.

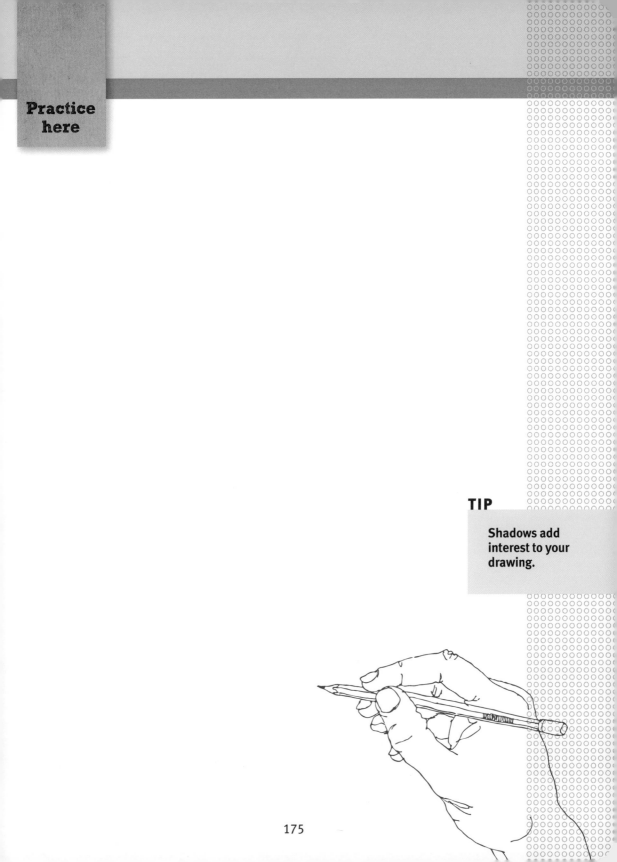

No car dashboard is complete without this nostalgic icon!

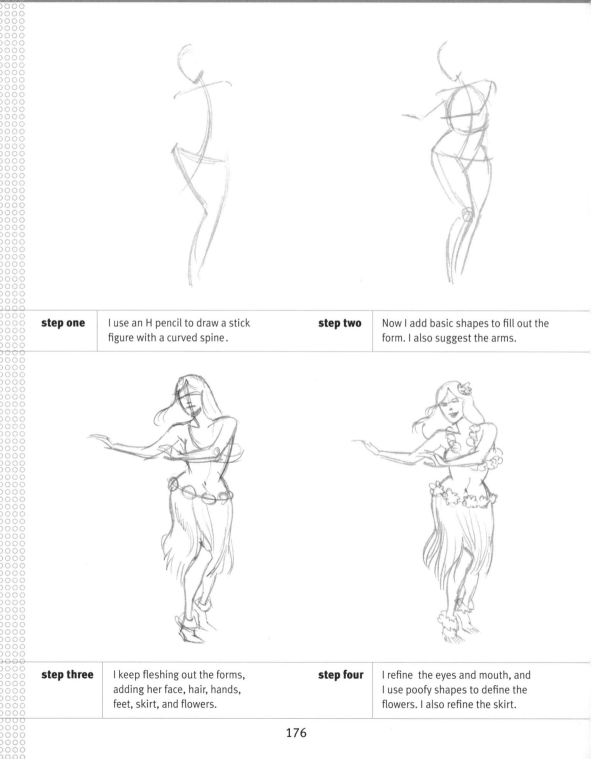

step one | I use an H pencil to draw a stick figure with a curved spine.

step two | Now I add basic shapes to fill out the form. I also suggest the arms.

step three | I keep fleshing out the forms, adding her face, hair, hands, feet, skirt, and flowers.

step four | I refine the eyes and mouth, and I use poofy shapes to define the flowers. I also refine the skirt.

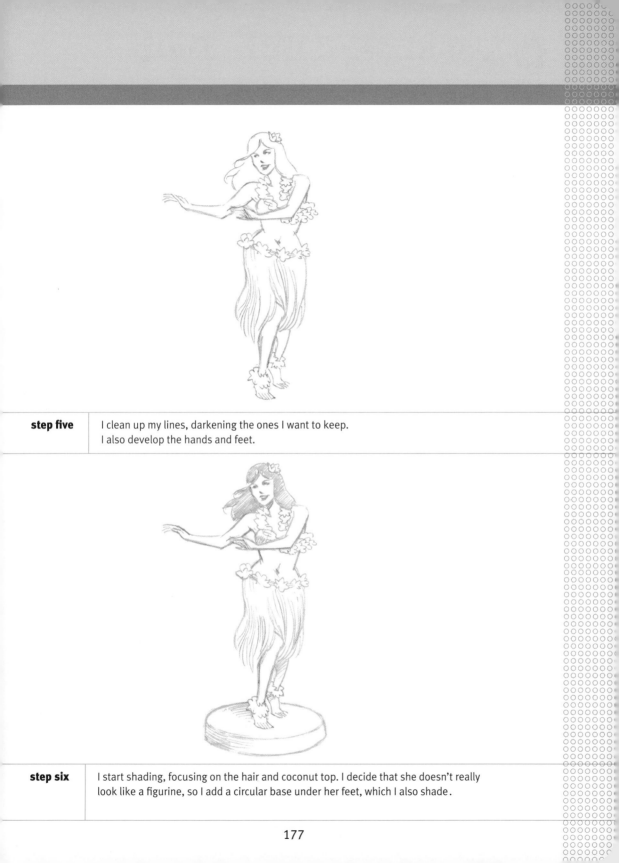

step five | I clean up my lines, darkening the ones I want to keep. I also develop the hands and feet.

step six | I start shading, focusing on the hair and coconut top. I decide that she doesn't really look like a figurine, so I add a circular base under her feet, which I also shade.

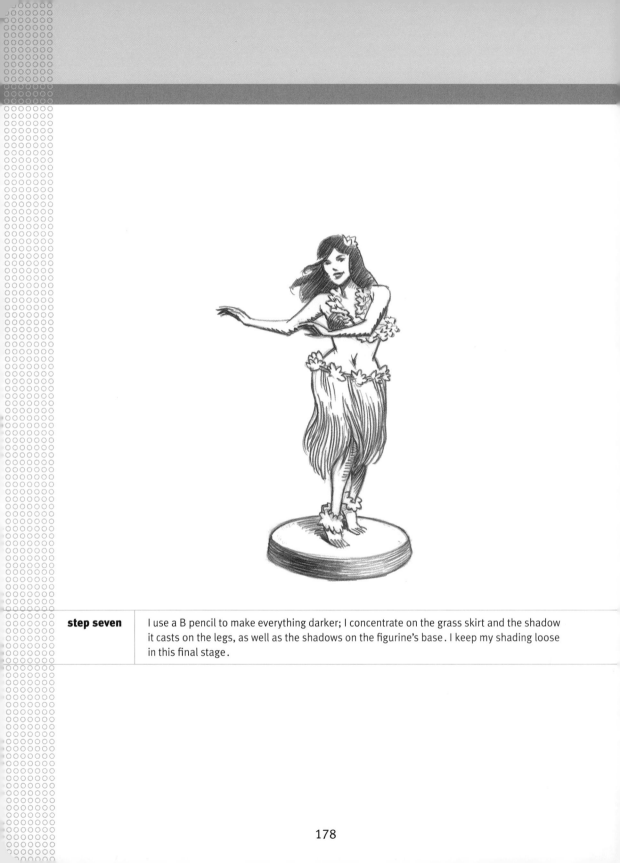

| **step seven** | I use a B pencil to make everything darker; I concentrate on the grass skirt and the shadow it casts on the legs, as well as the shadows on the figurine's base. I keep my shading loose in this final stage. |

TIP

The tip of the
nose usually
slants upward.

Just like the popularity of Indiana Jones's trademark hat, your drawings
will never go out of style.

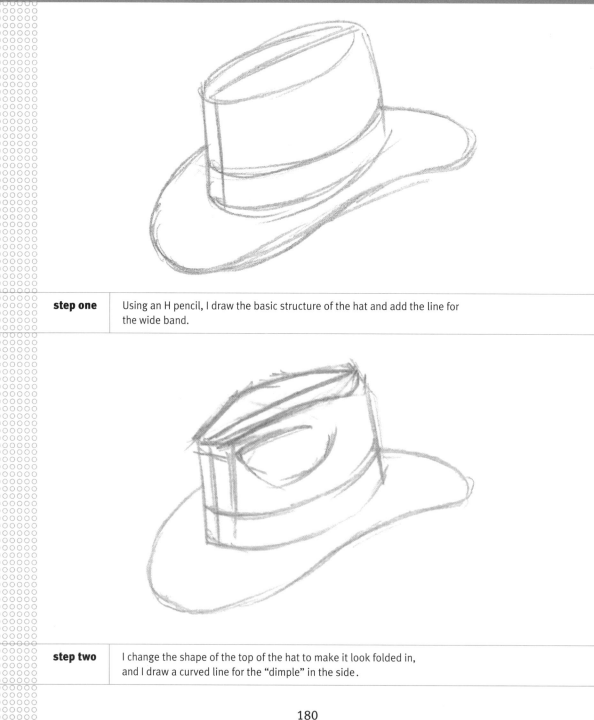

step one	Using an H pencil, I draw the basic structure of the hat and add the line for the wide band.

step two	I change the shape of the top of the hat to make it look folded in, and I draw a curved line for the "dimple" in the side.

| **step three** | I clean up the lines a bit, erasing some of the guidelines and adding the bow on the band. |

| **step four** | I clean up my lines even further, giving form to the hat with curved lines to show the brim's roundness. |

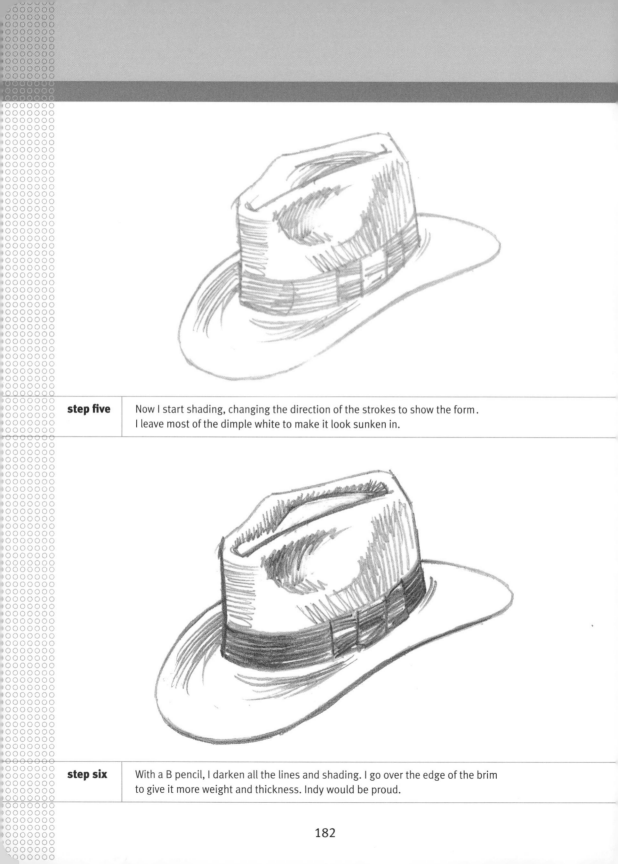

step five | Now I start shading, changing the direction of the strokes to show the form. I leave most of the dimple white to make it look sunken in.

step six | With a B pencil, I darken all the lines and shading. I go over the edge of the brim to give it more weight and thickness. Indy would be proud.

TIP

The simplest items in your home can be gathered to make an inviting scene.

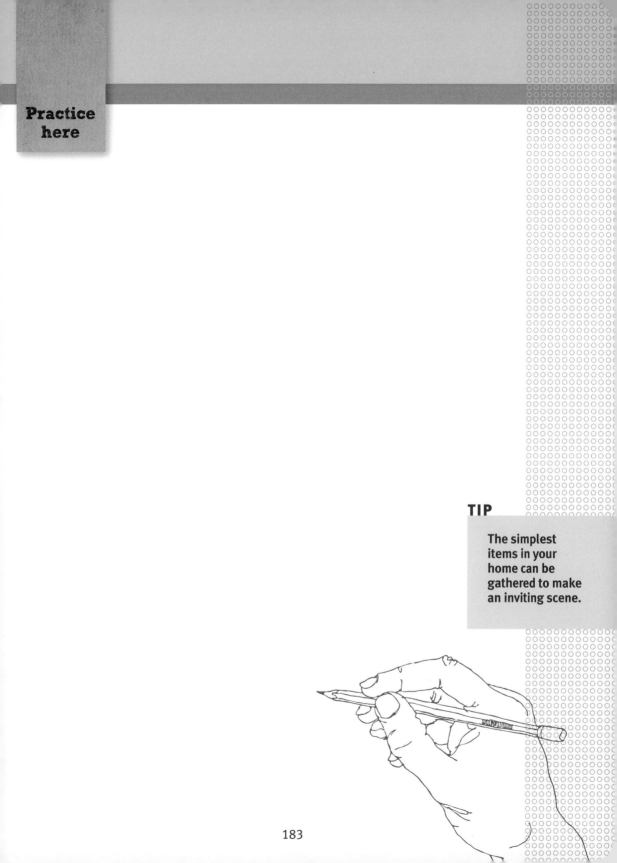

You might think drawing a neon sign in black and white wouldn't be as fun as drawing it in color, but I beg to differ.

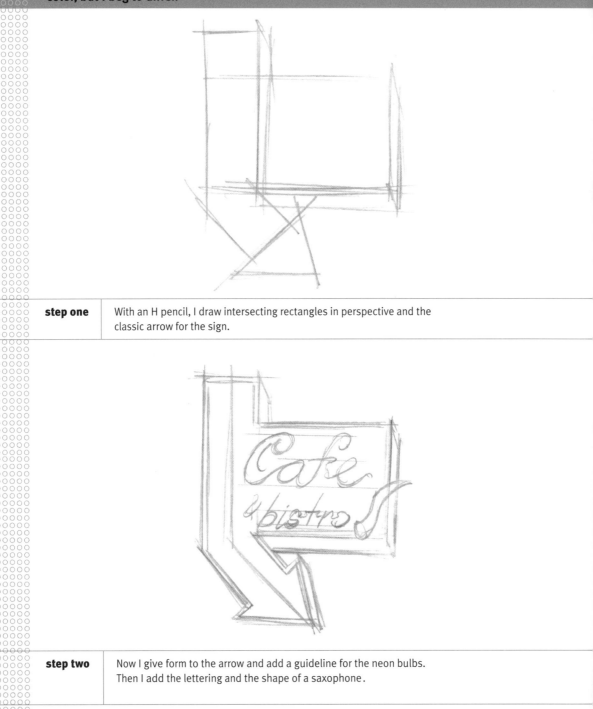

step one	With an H pencil, I draw intersecting rectangles in perspective and the classic arrow for the sign.

step two	Now I give form to the arrow and add a guideline for the neon bulbs. Then I add the lettering and the shape of a saxophone.

| **step three** | I use the guidelines on the arrow to place the neon bulbs, and I add guidelines at the tip of the arrow. Next I add the beams that support the sign. |

| **step four** | I give form to the lettering, making it look like a neon tube. I also give shape to the beams and add the small lights at the tip of the arrow. Then I round off the edges of the sign and detail the saxophone. |

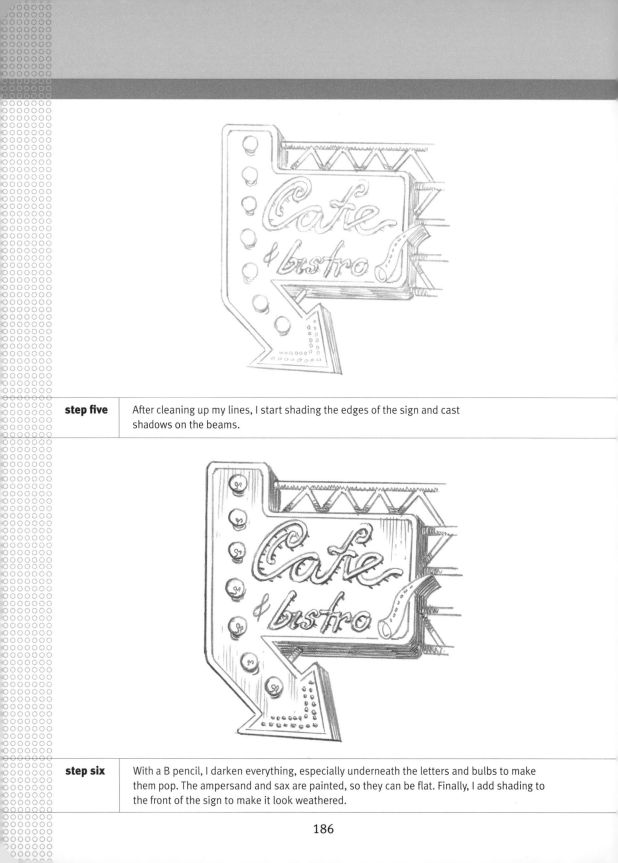

step five	After cleaning up my lines, I start shading the edges of the sign and cast shadows on the beams.

step six	With a B pencil, I darken everything, especially underneath the letters and bulbs to make them pop. The ampersand and sax are painted, so they can be flat. Finally, I add shading to the front of the sign to make it look weathered.

TIP

Using a variety
of strokes and
hand positions
gives a distinctive
value quality to
different shapes.

187

When drawing cars, you might want to start small. A Mini is a good place to start!

step one | I start by drawing a boxy shape with an H pencil. Then I add the headlights, wheels, windows, door, and grille.

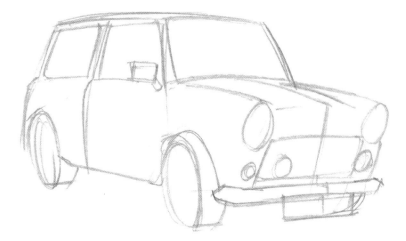

step two | I add details, such as the license plate, mirror, bumper, and the reflectors on the grille. I also round out the shapes and give them form.

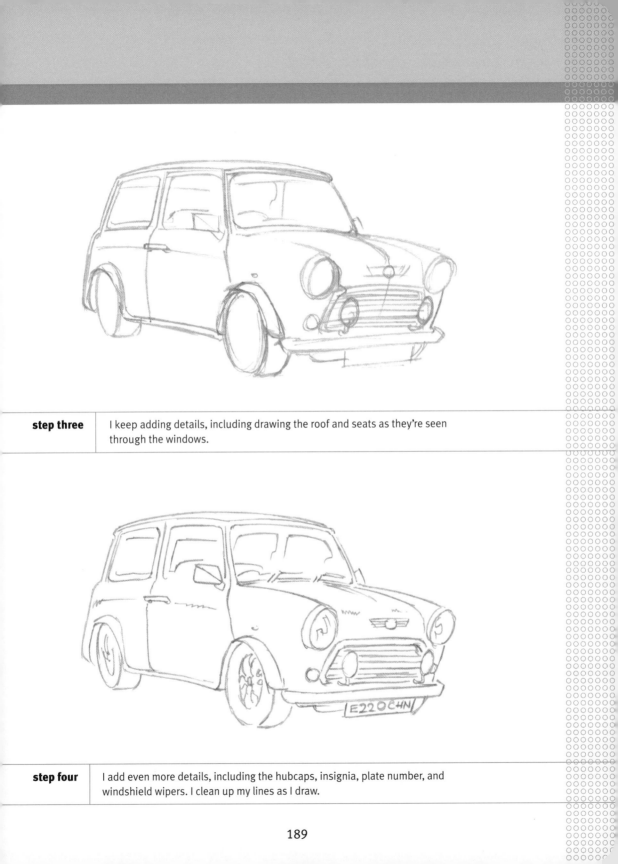

step three | I keep adding details, including drawing the roof and seats as they're seen through the windows.

step four | I add even more details, including the hubcaps, insignia, plate number, and windshield wipers. I clean up my lines as I draw.

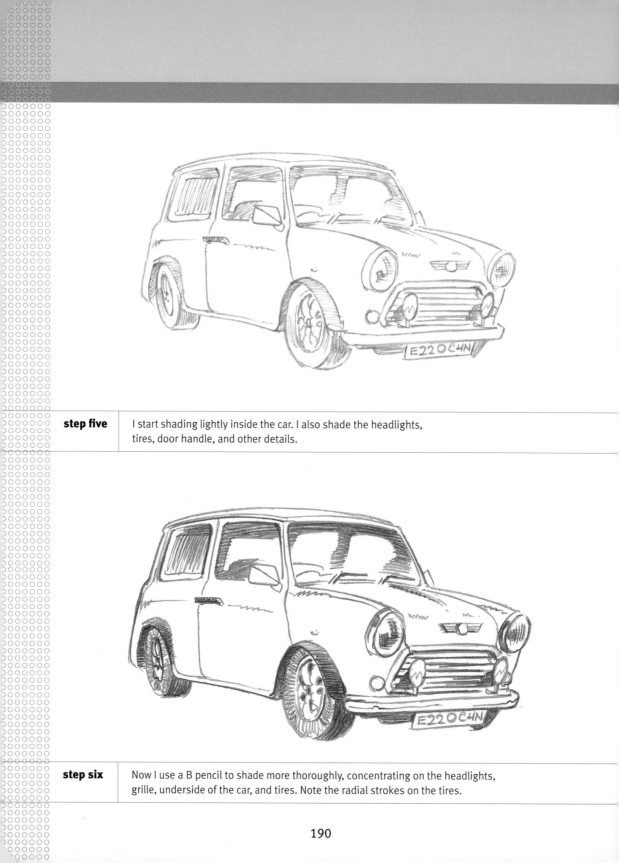

step five | I start shading lightly inside the car. I also shade the headlights, tires, door handle, and other details.

step six | Now I use a B pencil to shade more thoroughly, concentrating on the headlights, grille, underside of the car, and tires. Note the radial strokes on the tires.

TIP

Observation
is key to good
drawing.

Draw yourself a commanding figure of steel, ready to obey your instructions...

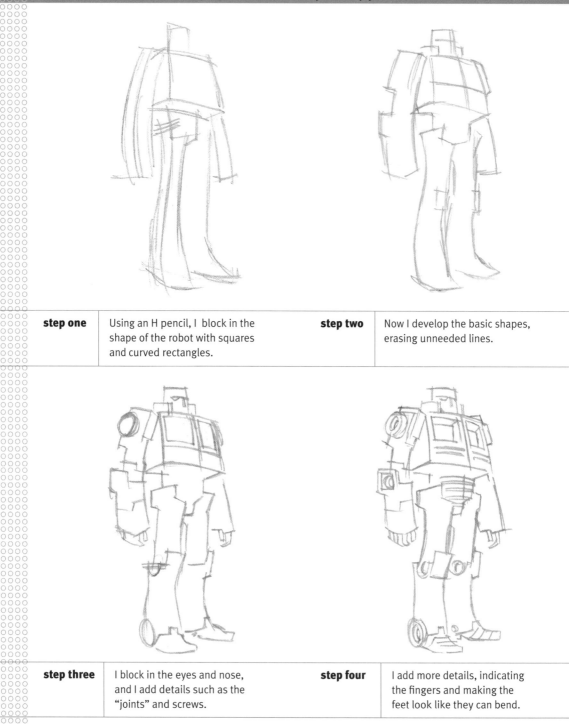

step one	Using an H pencil, I block in the shape of the robot with squares and curved rectangles.	**step two**	Now I develop the basic shapes, erasing unneeded lines.	
step three	I block in the eyes and nose, and I add details such as the "joints" and screws.	**step four**	I add more details, indicating the fingers and making the feet look like they can bend.	

step five	I clean up my lines and add more definition, especially to the kneepads, as they were looking too flat.

step six	Now I start shading, giving all the parts more form and dimension. Note that shading the top of each square in the chest makes the squares look concave.

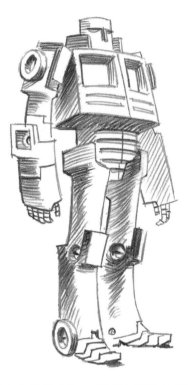

step seven With a B pencil, I darken all my lines and add shading with hatching and crosshatching. As a final touch, I make the fingers look flexible and add cast shadows under the upturned feet.

TIP

The direction
of your pencil
strokes should
follow the form of
the object.

④④ Piggy Bank

This portly pig will help you save your pennies for a rainy day.

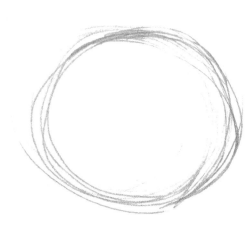

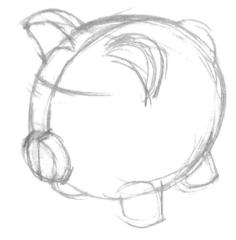

step one I start this money receptacle by drawing an oval with an H pencil.	**step two** I round out the oval a bit, making it a little more circular. Then I place the ears, snout, legs, and tail. I also add the facial guidelines.

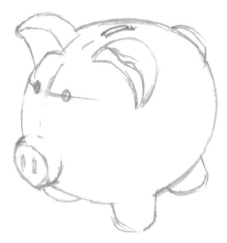

step three Using the lines as a guide, I draw the eyes and nostrils. Then I clean up my lines and add the coin slot.

step four	Now I darken the lines I want to keep and erase the rest.

step five	I start shading, mostly on the underside of the pig and inside the ears, nostrils, and coin slot.

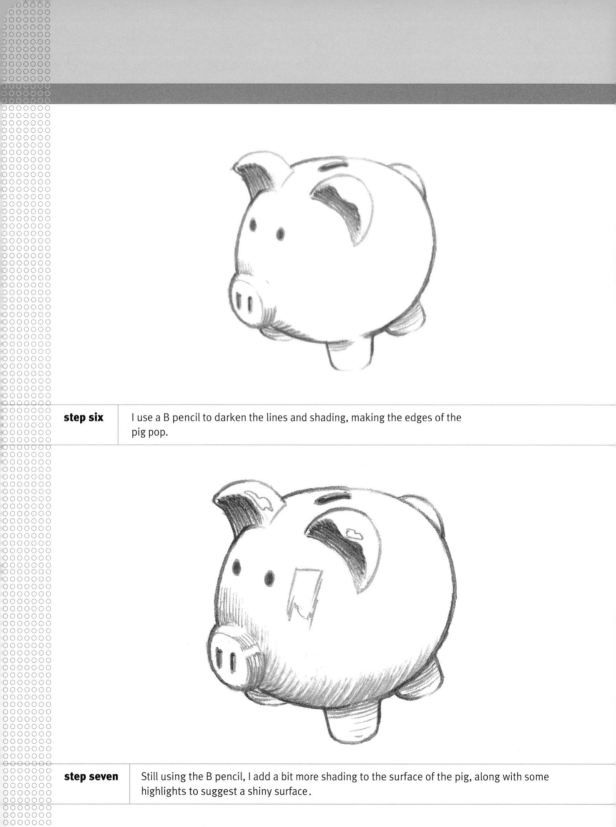

step six | I use a B pencil to darken the lines and shading, making the edges of the pig pop.

step seven | Still using the B pencil, I add a bit more shading to the surface of the pig, along with some highlights to suggest a shiny surface.

TIP

When value contrast is high and hard edges dominate one area, the viewer's eye will be directed to that area.

Record Player

Apparently, vinyl is making a comeback. When did it ever go away?

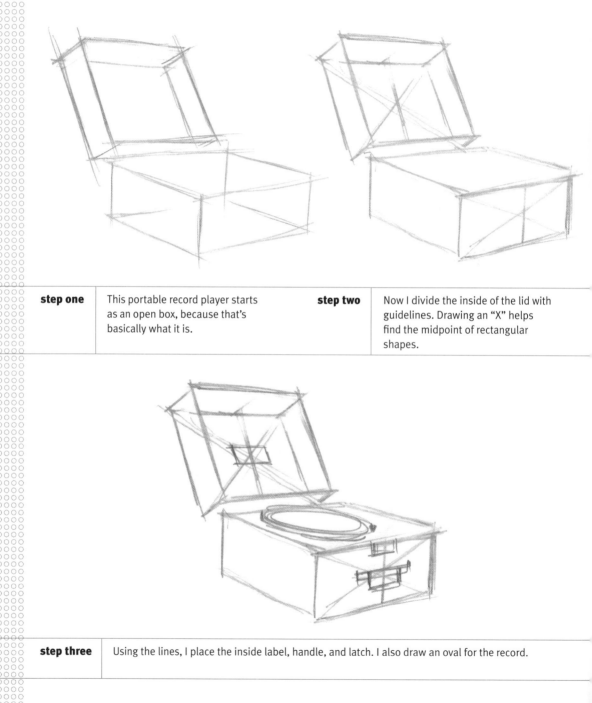

step one This portable record player starts as an open box, because that's basically what it is.

step two Now I divide the inside of the lid with guidelines. Drawing an "X" helps find the midpoint of rectangular shapes.

step three Using the lines, I place the inside label, handle, and latch. I also draw an oval for the record.

step four | Now I add more details, such as the top latch, a speaker, the corner bumpers, and the needle and knobs.

step five | I start to erase guidelines; then I round off the edges of the box and detail the corner bumpers.

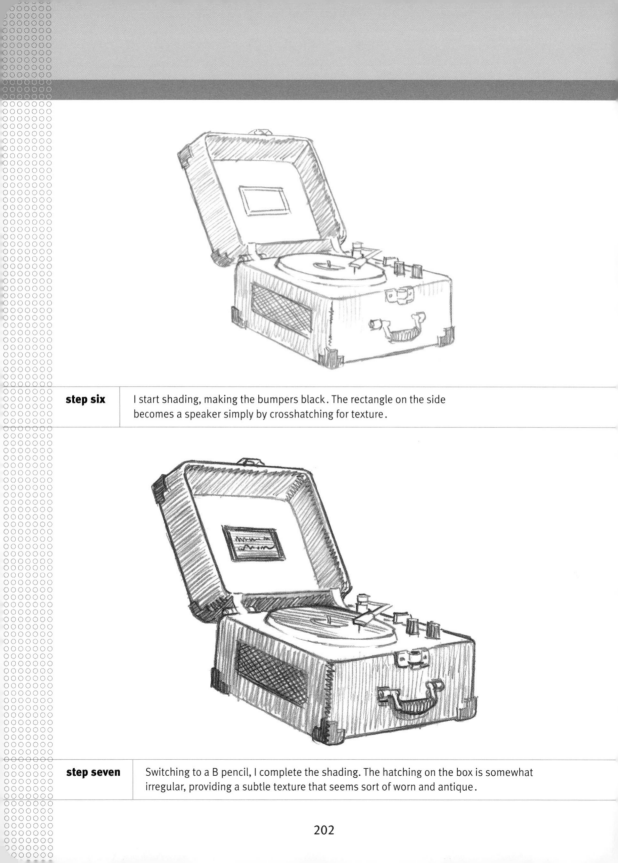

step six | I start shading, making the bumpers black. The rectangle on the side becomes a speaker simply by crosshatching for texture.

step seven | Switching to a B pencil, I complete the shading. The hatching on the box is somewhat irregular, providing a subtle texture that seems sort of worn and antique.

Practice here

203

Did you know that vanilla comes from plants in the orchid family? You do now!

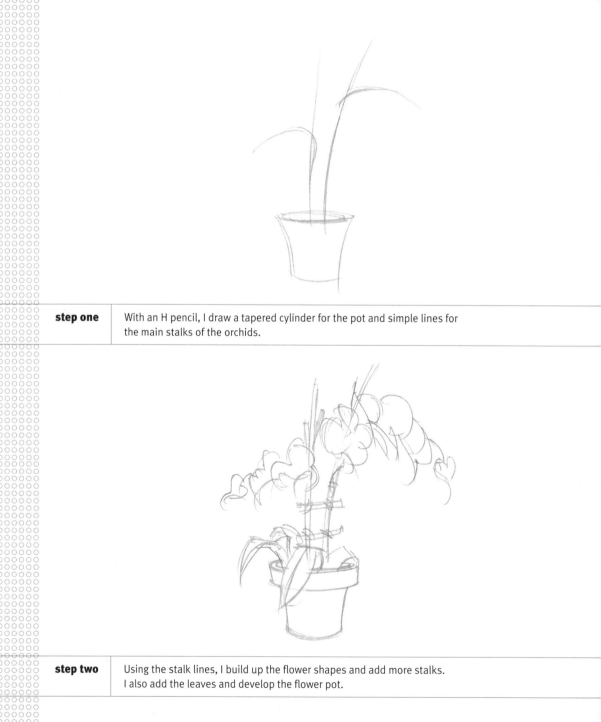

step one With an H pencil, I draw a tapered cylinder for the pot and simple lines for the main stalks of the orchids.

step two Using the stalk lines, I build up the flower shapes and add more stalks. I also add the leaves and develop the flower pot.

step three I continue developing the flowers, making them look more organic.
I also work on the pot, giving it a softer, more interesting shape.

step four Now I clean up my lines and add more details.
I also add texture to the pot with horizontal hatchmarks.

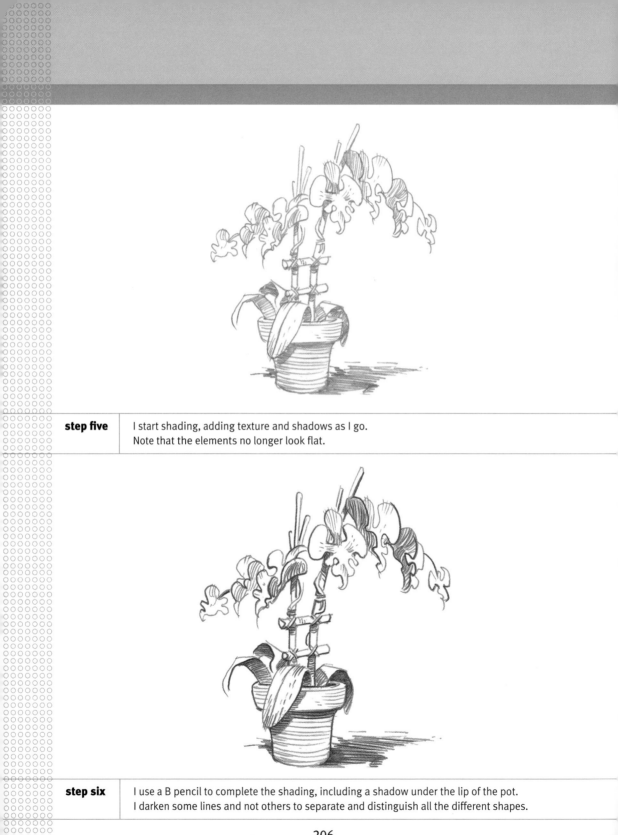

step five	I start shading, adding texture and shadows as I go. Note that the elements no longer look flat.

step six	I use a B pencil to complete the shading, including a shadow under the lip of the pot. I darken some lines and not others to separate and distinguish all the different shapes.

TIP

For graded shading, start with light, loose strokes, gradually increasing the pressure to create darker tones.

Retro Chair

Furniture makes a great drawing subject because it doesn't move. Or talk.

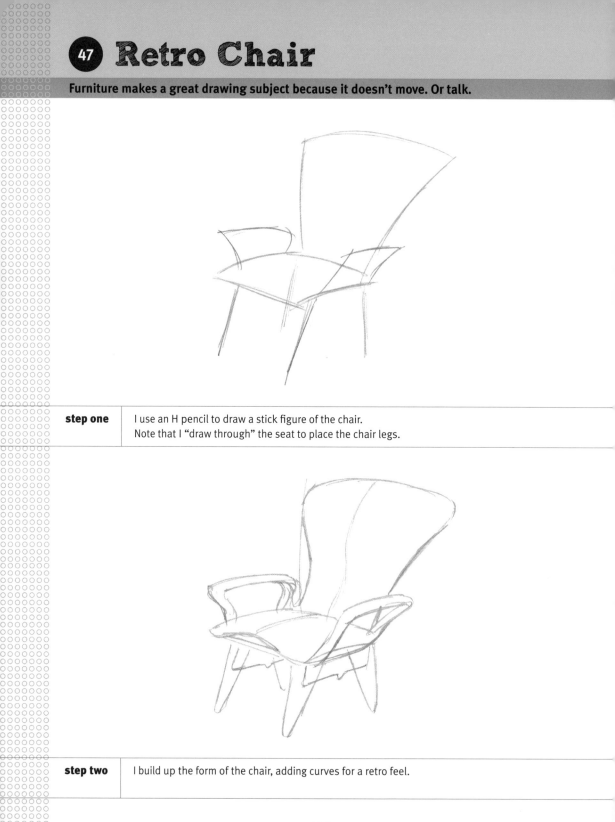

step one I use an H pencil to draw a stick figure of the chair.
Note that I "draw through" the seat to place the chair legs.

step two I build up the form of the chair, adding curves for a retro feel.

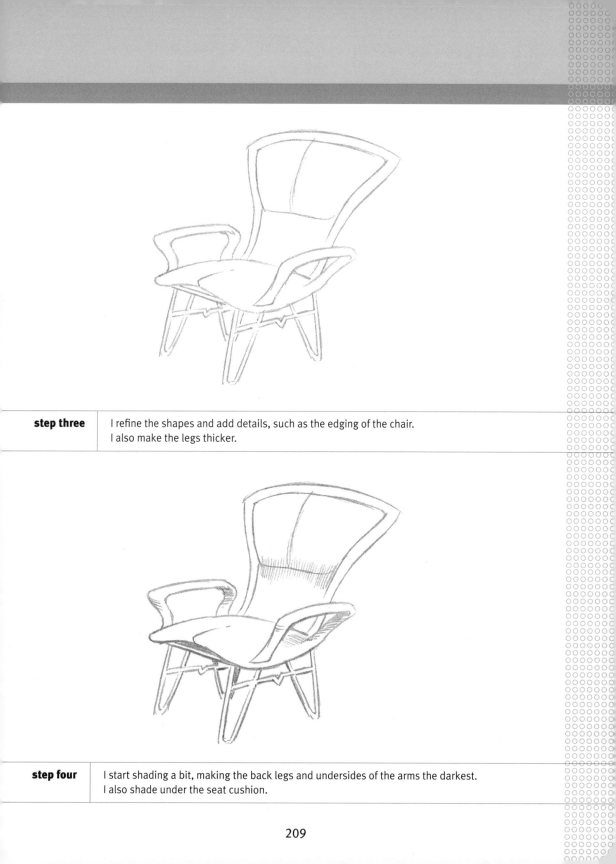

| **step three** | I refine the shapes and add details, such as the edging of the chair. I also make the legs thicker. |

| **step four** | I start shading a bit, making the back legs and undersides of the arms the darkest. I also shade under the seat cushion. |

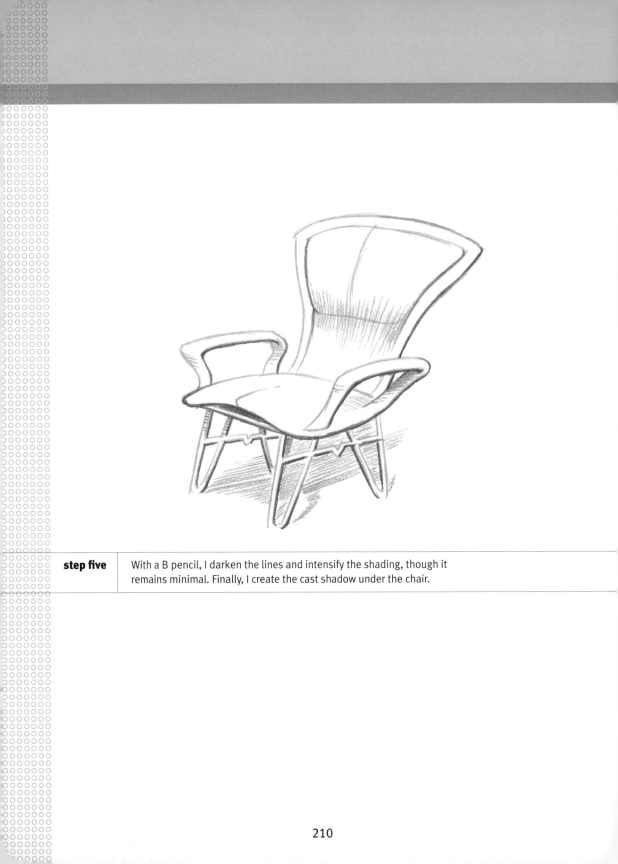

step five | With a B pencil, I darken the lines and intensify the shading, though it remains minimal. Finally, I create the cast shadow under the chair.

TIP

Visit museums
and galleries in
person or online
to get inspired.

What's better than a pair of fez-wearing monkeys?
A pair of fez-wearing monkeys that also make your food taste better!

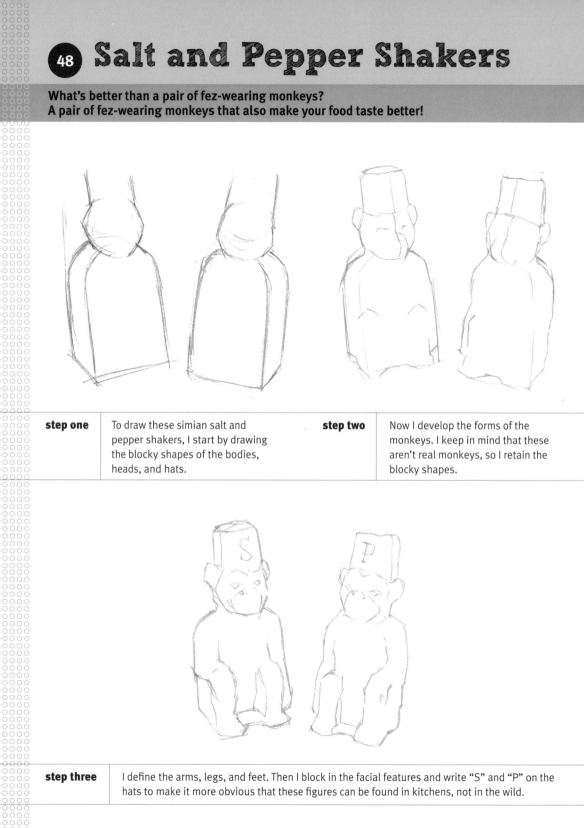

step one To draw these simian salt and pepper shakers, I start by drawing the blocky shapes of the bodies, heads, and hats.

step two Now I develop the forms of the monkeys. I keep in mind that these aren't real monkeys, so I retain the blocky shapes.

step three I define the arms, legs, and feet. Then I block in the facial features and write "S" and "P" on the hats to make it more obvious that these figures can be found in kitchens, not in the wild.

| **step four** | Now I indicate the fingers and toes, as well as the mouths. I also add dimension to the letters on the hats. |

| **step five** | I clean up my lines, erasing those I don't need and darkening those I want to keep. |

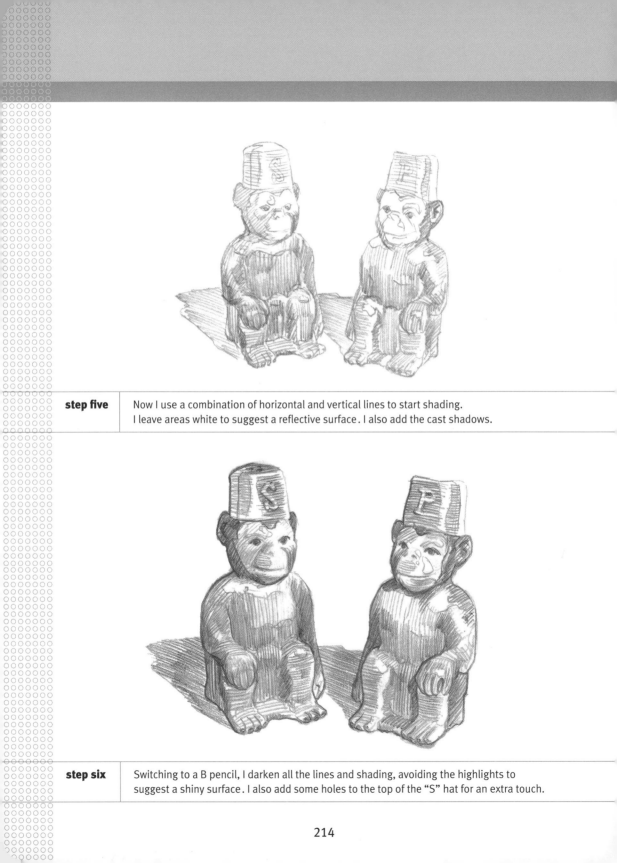

step five | Now I use a combination of horizontal and vertical lines to start shading. I leave areas white to suggest a reflective surface. I also add the cast shadows.

step six | Switching to a B pencil, I darken all the lines and shading, avoiding the highlights to suggest a shiny surface. I also add some holes to the top of the "S" hat for an extra touch.

TIP

Not all highlights
are pure white.

step one	High heels like these have a very graceful nature, so I start by drawing some elegant curved lines with an H pencil.	**step two**	Building on my lines, I suggest the toe and the heels.

step three	Now I make the heels thicker and construct the back of each shoe.

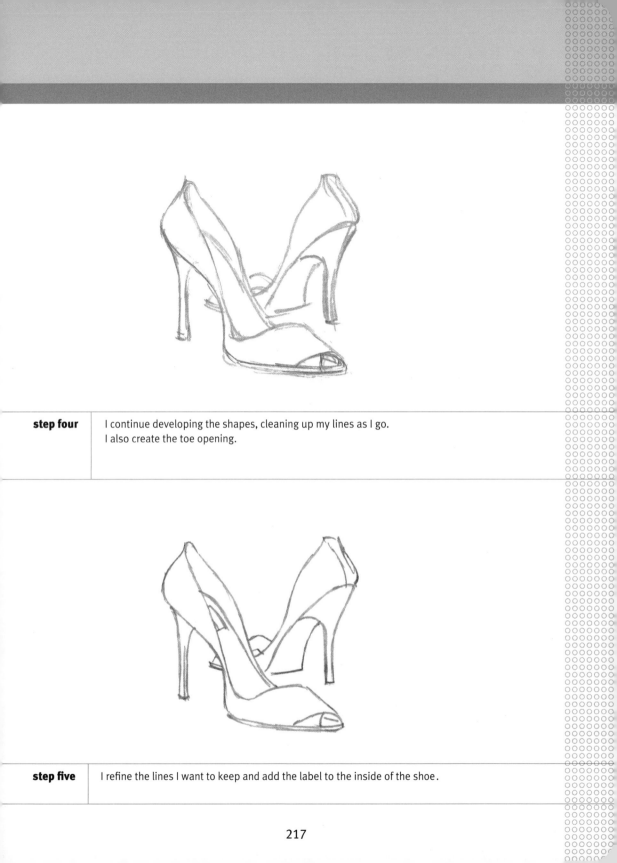

| **step four** | I continue developing the shapes, cleaning up my lines as I go. I also create the toe opening. |

| **step five** | I refine the lines I want to keep and add the label to the inside of the shoe. |

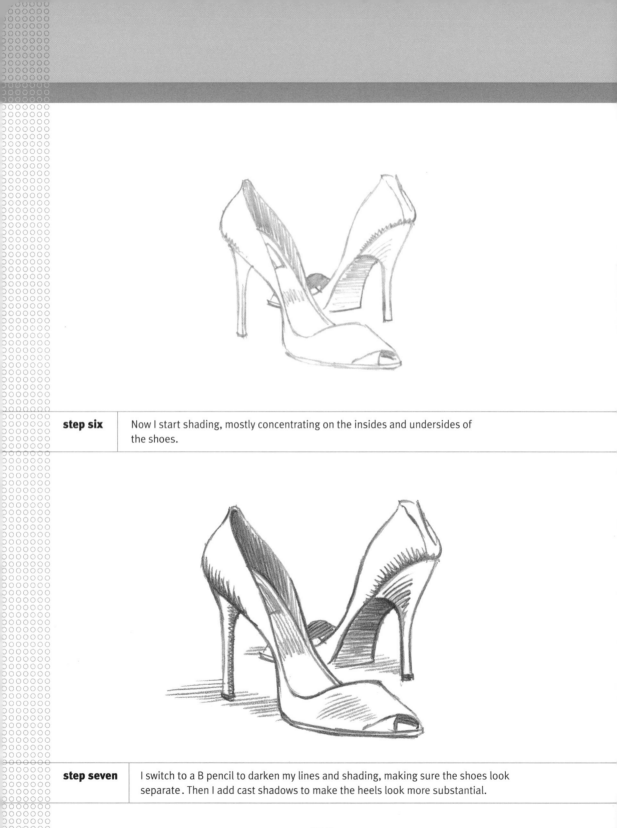

| **step six** | Now I start shading, mostly concentrating on the insides and undersides of the shoes. |

| **step seven** | I switch to a B pencil to darken my lines and shading, making sure the shoes look separate. Then I add cast shadows to make the heels look more substantial. |

Practice
here

TIP

Wipe the tip of
your pencil after
sharpening,
so remaining
particles don't
mar your clean
drawing.

219

Although their availability is limited, you can now own one of these classic cars in seven simple steps.

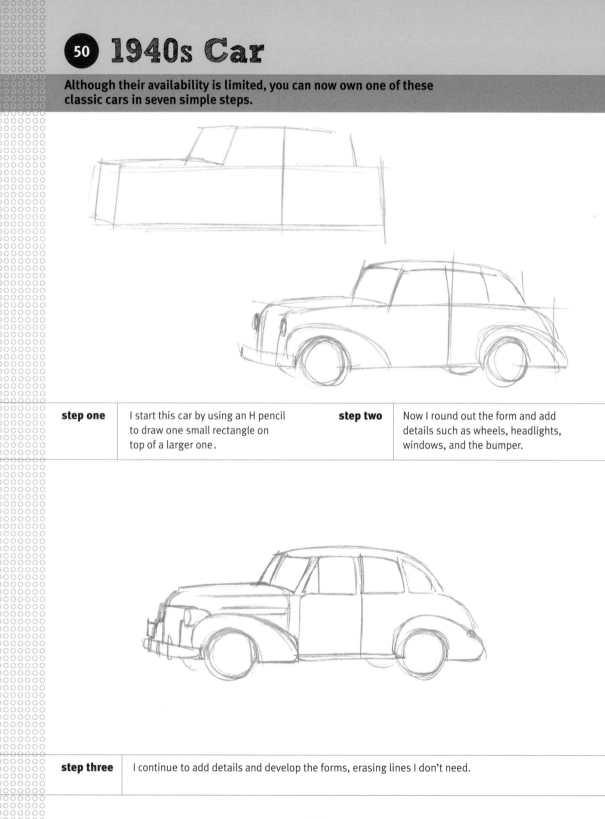

step one I start this car by using an H pencil to draw one small rectangle on top of a larger one.

step two Now I round out the form and add details such as wheels, headlights, windows, and the bumper.

step three I continue to add details and develop the forms, erasing lines I don't need.

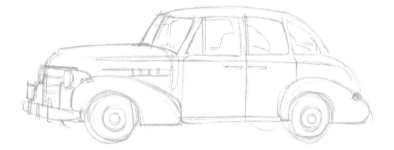

step four | I add details to the wheels, grille, and body of the car.
Then I draw the seats inside.

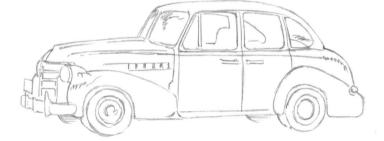

step five | I clean up all my lines, refining and adding more details as I go.

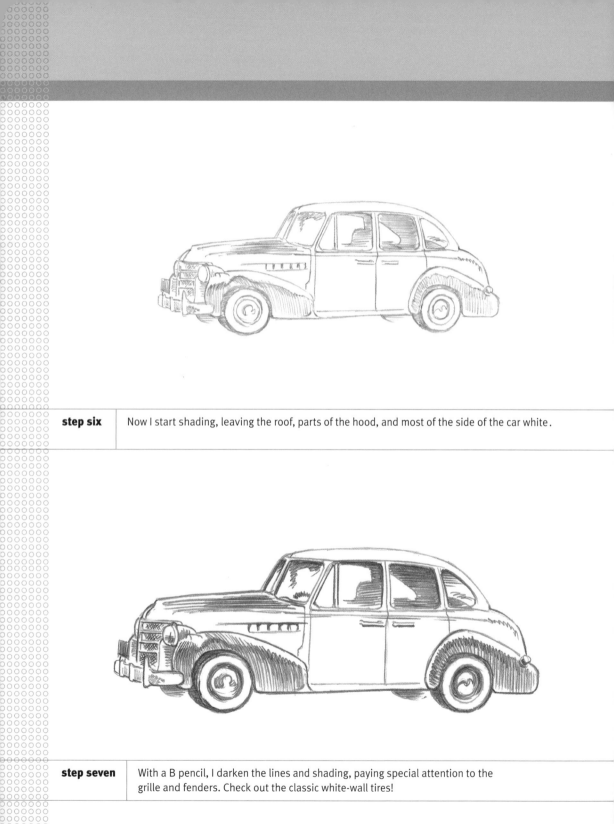

step six | Now I start shading, leaving the roof, parts of the hood, and most of the side of the car white.

step seven | With a B pencil, I darken the lines and shading, paying special attention to the grille and fenders. Check out the classic white-wall tires!

TIP

If you want to
improve your
drawing skills
. . . practice,
practice, practice.

That's All Folks

Well, that's about it for this book. But there are still plenty more things to draw. Just draw everything as often as you can, from the girl sitting across from you to a crumpled soda can on the ground to your own two feet.

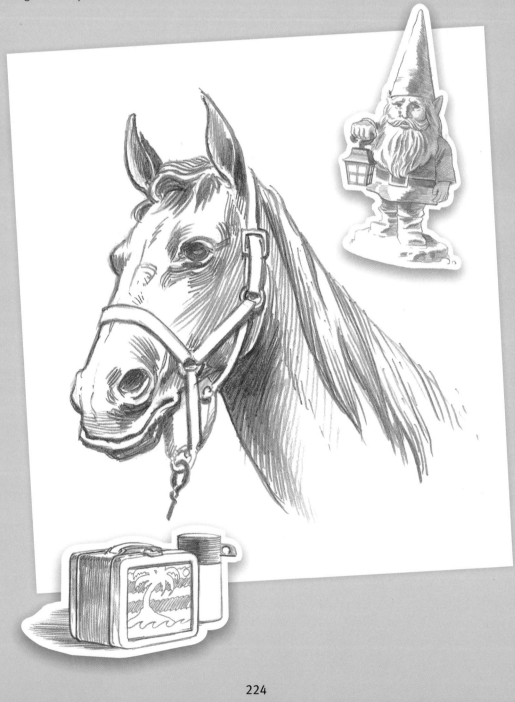